# DANIEL S. KAUFMAN

**SIMON & SCHUSTER**
New York  London  Toronto  Sydney  Tokyo  Singapore

TO BE A MAN

TO BE A MAN

TO BE A MAN

TO BE A MAN

TO BE A MAN

TO BE A MAN

TO BE A MAN

TO BE A MAN

**SIMON & SCHUSTER**
Rockefeller Center
1230 Avenue of the Americas
New York, New York 10020

Copyright © 1994 by Daniel S. Kaufman

Designed by Deirdre Amthor
Manufactured in the United States of America

1   3   5   7   9   10   8   6   4   2

Library of Congress Cataloging-in-Publication Data
is available.

ISBN: 0-671-88107-8

To my *men*tors:

Robby Miller, 1964–1986
Leonard Bernstein, 1918–1990
Michael Kaufman, 1924–1992

You each helped me *to be a man.*
I will miss you always.

D.

# Acknowledgments

This book could have been completed only with the help of many people. I would like to acknowledge some of them.

I would first like to thank Lewis Watts, my photography teacher, who inspired my confidence to pursue this project. I would also like to thank Kathleen Moran, Michael Kimmel, and Hillary Vartanian for their consistent support and encouragement. Thanks also to Ben Chesluk who first asked me about male identity. Finally, it was Karen Holden who went out of her way to introduce this work to the publishing world.

I would like to recognize and thank Patty Leasure, my editor, and Linda Cunningham, the vice-president of my very distinguished publisher, for their belief and commitment to this project. I also want to thank my agent, Al Lowman, who provided support, advice, and enthusiasm when it was most needed.

I was helped enormously by Guy Vinson and the staff of the CED Photo Lab, at UC Berkeley, who put up with endless questions, late nights, and rule bending in order for me to complete this project.

Traveling across the country, I imposed on many new and old friends who put me up and fed me when I had virtually nothing but a driving passion to explore the issues laid out in this book. I want to thank Libby, Scott & Elizabeth, Suzie, Ted & Heather, Greg & Shaun & Myrna, John & Dana, Cole & Willa, Carl & Mary, Jennifer & Patsy, and Anthony for their hospitality and welcome across this country when I was lonely and lost. I also want to thank my brother, Bob, for his support and many errands he ran for me throughout the process of creating this book.

I want to thank John Turner specifically for the beautiful work he has done on this book.

Finally, I want to thank the hundreds of men and women to whom I spoke on such deeply personal subjects. Thank you for trusting me, confiding in me, and helping to create this beautiful work. Thanks also to the many people who led me to those whom I photographed and interviewed. We did this together.

—Danny Kaufman

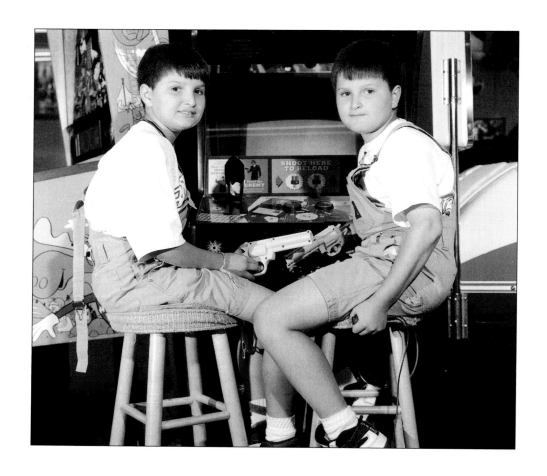

Men are the same
as women. Women
can do anything a man
can do.

men like to do construction work
and stuff.

men don't like to clean house
and stuff women do.

# *What Is It to Be a Man?*
# *What Is It to Be a Man?*
# *What Is It to Be a Man?*
# *What Is It to Be a Man?*

IMAGINE THAT YOU WERE a boy growing up today, ready to take the leap from boyhood to manhood. What would you become? How would you behave? How would you maintain a sense of masculinity when all that was traditionally defined as being male is now changing drastically? These very questions are relevant not only to the boys growing up today, but also to men of all ages who cope daily with the conflicts of a new social order. And yet the issues and questions surrounding male identity are rarely communicated; consequently, modern gender definitions seem to be evolving in many conflicting and surprising directions.

In *To Be a Man,* I have set out to record and present the multi-faceted and complicated nature of the way men perceive themselves. For almost two years, I traveled across the country, meeting people, discussing male identity, and encouraging men to express themselves both visually and verbally. I started in Texas, then went to Louisiana, and then up to New York City. Later I wandered from the top of Washington State, down to the bottom of California, and later still from north Maine to south Florida. In

between the coasts, I visited several other states and met a diverse sampling of the American male population.

I discovered these men in much the same way you will in the pages that follow. With few exceptions, these men were complete strangers to me. I approached men of all ages (ten years old to ninety-two years old) and from all walks of life (many ethnicities, socio-economic, and philosophical backgrounds), and I asked them the same question: WHAT IS IT TO BE A MAN?

Not wanting to lead their responses, I asked an intentionally vague and ambiguous question, which could be interpreted in an infinite number of ways: *What is it like? What does it take? What does it mean? What is a successful man? When do you become a man? What is the difference between a man and a woman? Between a man and a boy? What is expected of men? What is the role of a man? What makes men unique? What do you like about being a man? Are there advantages to being a man? disadvantages?* The answers I got are strikingly honest and passionate: they are often disarming, sometimes amusing, and always enlightening.

I started this project in order to offer an unusually candid glimpse into what men think. But over the course of my early encounters, it became clear that a purely written interview format would not work on its own. Words could mean so much more if the reader had an idea who was saying them. But neither would a singularly visual format tell as complete a story—especially considering the potentially manipulative aspects of photography. Traditional portraiture freezes a photographer's split-second, external observation of another subject for an eternity, and considers that image to represent a true likeness. But I could not represent all that I needed to without delving deeper into the subject's background, personality, and perspective. Consequently, I developed a methodology which might be thought of as *bio-photography*. Here each portrait would be comprised of an interview, a handwritten statement, and a collaborative photographic self-portrait—a formula

which I believe offers a far more complete and less intrusive presentation and insight into these male subjects.

As a photographer, I was the most comfortable with film as my visual medium for depicting manhood and male identity. But as a student of social science, I was painfully aware of the objectifying nature of the camera. Photography so realistically portrays reality onto two dimensions that a viewer is tempted to view such a picture as being practically and undeniably real. But actually, nothing could be further from the truth. Every photograph rips a split-second instant image out of the context of the time-continuum, and puts it into two dimensions with no sense of the before or after. That instant is supposed to tell all. But it doesn't.

Among the manipulative aspects of photography is the way that a camera guides the viewer into perceiving the subject as an object rather than as a person. The camera dictates the gaze of the viewer and determines the angle and the point of view from which the subject is seen. For these reasons it seemed wrong for me to use a camera as my principal mode of visual expression, as it would make me the director, framing the subjects on my whims and through my own presuppositions.

The camera also has limited vision; the celluloid frame can only hold so much information. It is therefore up to the camera operator to select not only the moment, but also the content of the frame. The traditional photographer chooses which elements are most important, how they should be placed, what should be focused on, and what should be left out. These considerations dramatically change the story of an image, and each of these decisions is subjectively made by the photographer. Therefore, using photography represented a particularly dangerous method of visual expression for me because I did not want to objectify or fabricate anybody.

But what if I did not take any of the photographs, but was rather the facilitator of a photographic *self-portrait?* This way, if such a constructed image was inevitable, at least I would not be the one to construct it. And, rather than denying the manipulative elements

of composing a photographic image, I would actually be embracing them. As self-portraits, these images gain new relevance. By insisting that the subjects create their own photographs, these men inevitably expose more of their thoughts and emotions since they themselves have to take responsibility for the images. There is no longer a single director, who uses a modern instrument like photography to further his/her own agenda. Instead, the camera becomes the instrument of many as a means for their self-expression and celluloid is then the conductor of vulnerability and identity.

The subject therefore became the decision-maker. He had to choose where, when, and how he wanted to be photographed—I offered myself as a model for him to frame upon. Together we explored the many framing and lighting options in photography: I moved closer to or farther from the camera; we set the tripod very low looking up, or very high looking down. In more than one case, we tried every idea that either of us could think of, but in each case, the final decision on how to frame the photograph rested with the subject.

With self-portraits I had now expanded the question to include a very different idea of visual identification. As self-portraits, I now asked men: *How do you see yourself? How do you present yourself?* Since the subjects chose the circumstances of their portraits, they had the freedom to explore the notion of appearance, posture, and gaze. Did these men consider their clothes or gesticulations? Were they performing as idealized personae for the camera or were they acting less consciously? The backgrounds and positions, the facial expressions and postures, the lighting and props—these elements all became part of the expression and identification of my subjects.

The key to making this a true self-portrait was to give the final control to the subject. This was achieved via the use of a thirty-foot-long cable release cord. The male subject could then actually fire off the shot himself at the instant he was most happy with,

when his expression and posture were as he wanted. I believe that one of the principal elements of my art was the very act of encouraging men to express themselves, and to do so without my intervention. It took some discipline not to correct the men from breaking basic photographic conventions. For instance, photography at high noon is a particularly difficult task, especially if the subject is wearing a hat. And yet so many of the ranchers wearing cowboy hats or the field workers wearing baseball caps insisted on shooting in midday sun with their hats on. At first, I fought them by suggesting other placements or times of the day, or by using fill flash to compensate for the shadows, but ultimately I gained some perspective on the poetic nature of their visual statement.

In Stormy Pruitt's self-portrait (below) we see a man made virtually faceless by the shadow cast by his cowboy hat. Technically, this is the sort of pitfall that every photographer avoids, and yet there is something telling about a man living in the tradition of the *Marlboro Man* to have no face. Other men insisted on being

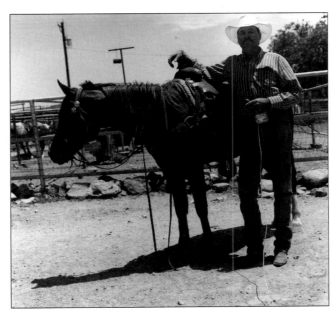

photographed with the bright afternoon sun behind them, making the level of photographic contrast very difficult to accommodate. But in the end, these breaks from convention make for revealing images and fascinating viewing.

I chose to include the cable release cord in each image for several reasons. Of course I wanted to draw attention to the fact that these are self-portraits, but just as importantly, I wanted to remind the viewer continuously of the formal construction of each image. The cord makes the presence of the camera obvious, and therefore brings all of the performance aspects of photography out into the open.

The cable release cord also displays an element of masculinity which is often identified and attacked: control. The stereotypical male mystique portrays men as being domineering, controlling, and powerful. The use of the cable release cord can be interpreted as an extension of that strength. Some men use it with timidity, and some with brute force. Some squeeze the shutter with the exasperation with which they face the world, and others do it with a seeming innocence. Finally, many men are embarrassed by this control. Perhaps this mixture of external expression betrays a much bigger and deeper element of male culture.

There is an ethical question facing documentary or photojournalistic photography. Such work has a tendency to encourage viewers to forget about the presence of the camera and photographer at each event. Many times the work will try to capture a subject without him or her knowing it, in order to depict the photographer's experience of an event. Such images can be infinitely misleading, especially because modern society seems to trust images captured on film as being undeniable—if an event is there in black and white (or color), it would seem undeniable that it actually happened. I did not want to partake of or encourage this overconfidence in photography, and so by including a piece of the camera in each image (the cable release cord) I am attempting to bring out the self-consciousness of each image.

I chose a particularly clumsy type of camera. By using a medium-format camera rather than just a point and shoot 35mm camera, not only did I get increased detail and depth from having a larger negative, but I also slowed the process of taking the photograph down to a virtual crawl. Together the subject and I would choose our site to take the image; I would then start my ten- to twenty-minute process of setting up the camera, all the while speaking of masculinity, photography, and/or the weather. Then I would show him how to move the camera so as to be able to frame the image as he would like; next I would take several light readings. Finally I would pose for the subject by moving according to his direction. I always insisted that the subject actually come around and look into the camera so that he could set up the photograph as he most wanted it to be. This was not nearly as simple as *smile for the camera.* Slowing down the process of picture taking made it easier for the subject to recognize the various possibilities of each image, including what to incorporate, how close to be to the camera, and from what angle to be seen.

I have chosen to include the square, black frame surrounding each image in order to accentuate the formality of this photographic window. I wanted to remind the viewers that once again what is enclosed in the photograph has been chosen, and that just like looking in a window of a house, you are seeing only one of many possible views. But the most important reason for including that black frame is to show that I performed no darkroom manipulation. There was no cropping, nor any negative layering. The final photo is as close as possible to the image of our original conception.

Of course I have an undeniable and unavoidable influence on each image, which I attempted to minimize. I chose the subjects, and I chose when to approach them. I brought all of my opinions with me to each photo shoot, even though I did everything I could to hide them. I chose the camera, the film, and the type of processing. As the facilitator, I made suggestions and made sure that

the film would be properly exposed, and during that process, I am sure that I brought my own sense of aesthetics and my own expectations about what I might find. And in the end, I usually ended up determining which image to use. Nevertheless, I did make a genuine attempt at collecting self-portraits, rather than just photographing the subjects myself.

What was also of immediate interest was the inclusion of handwritten expressions with the images. In a very real sense it is the specific words of the men's statements that are interesting, and yet by including those words in their own handwriting the reader is given a different glimpse into their personalities. We can explore their literacy, their attention to details, their general sloppiness, neatness, or even their nervousness. This is yet another element which takes *bio*-photography one step further from a simple frozen frame. The writing further contextualizes the image.

A final addition to the photographic self-portrait and handwritten expression is the inclusion of a simple biographical sketch that further illuminates the subject. Each man filled out a simple questionnaire which provided standard details such as: name, age, race/ethnicity, occupation, education, relationship status, where born, where raised, where presently reside, class or socio-economic background, any other defining characteristics or experiences, and a philosophical statement. The final two questions were offered as openly interpretive templates for the men to further describe themselves. This added information offers a considerably grander perspective on these two-dimensional images by providing a third dimension.

While compiling this book, there were many occasions when I was extremely surprised by details revealed in the questionnaire. Often the written expression was more or less literate than I had expected; sometimes the education was different than anticipated or the life philosophy surprising. In the end, these revelations always reconfirmed the age-old adage—there is more than meets the eye.

Each of these three elements (the self-portrait, the handwritten statement, the biographical sketch) invites us not only to look deeper and differently into each of the subjects; they also provide a fortuitous opportunity to make social comparisons. If we were to switch the statements with the images, what would that tell us? Would the image match the writing? the biographical sketch? What might that say about our expectations of certain appearances? What are our own inherent prejudices about what it is to be a man?

In the portraits that follow, contemplate the images and expressions, the way the men pose for their photographs, and how they confront the issue of their identity. Notice their chosen words, poses, and environments, and appreciate their honesty and the telling way in which they felt comfortable enough to break masculine conventions and place themselves in front of the camera and on these pages.

In *To Be a Man*, I have tried to provide a forum for visual and verbal expression, to allow men to explain who and what they are. Most likely this book will do little to consolidate a singular definition of masculinity, but hopefully it will provide some insights into the male experience in America today. Perhaps through these men's descriptions and statements about themselves a new dialogue can be opened among men and between men and women on a level of mutual respect, understanding, and compassion.

*I FEEL THAT AS WOMEN STRUGGLE TO FIND SELF-REALIZATION, THE ROLE OF MAN IS TO PROVIDE STABILITY TO HIS FAMILY, OR HIS COMMUNITY. I BELIEVE MEN ARE BEST EQUIPPED TO FURNISH A COMFORTING SENSE OF CONTINUITY — A NEVER CHANGING, QUIET, RELIABITY.*

***Name:*** Eric N. Grant   ***Age:*** 42   ***Occupation:*** Fish Processing Mechanic   ***Race/Ethnicity:*** Caucasian   ***Where Born:*** Ft. Kent, Maine   ***Where Raised:*** Presque Island, Maine   ***Presently Reside:*** Rockland, Maine   ***Relationship Status:*** Married 17 years, 4 children   ***Education:*** High School Graduate   ***Socio-Economic Class:*** Working poor   ***Any Other Defining Characteristics or Experiences:*** Veteran, three tours in Viet Nam   ***Philosophical Statement:*** Trying to do the best I can for my children.

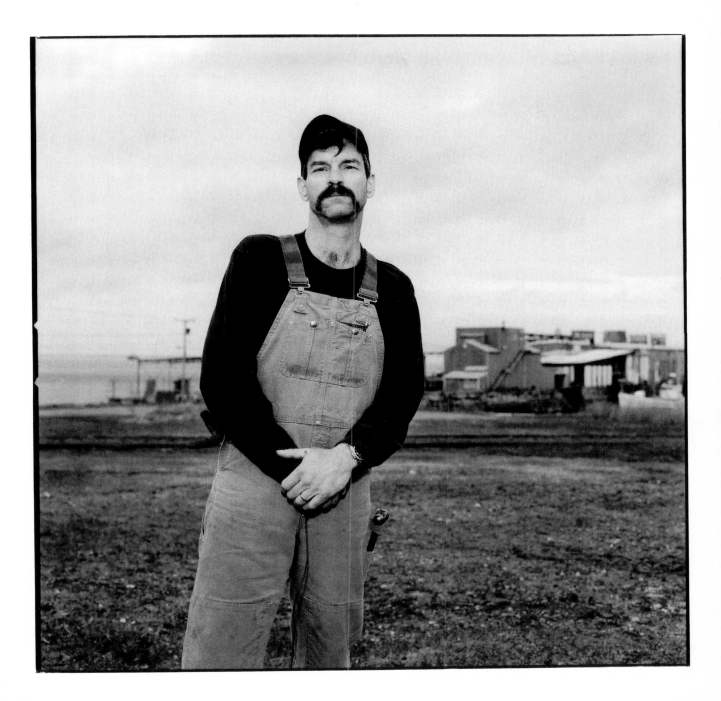

Realize women are equal to become a man,
Love a woman to delight in being a man,
Protect and care for family to fulfill the role of a man,
Be fierce in life's battles to know the power of a man,
Be gentle and humane to reach the highest state of a man.

*Stephen Chrystie*

**Name:** Stephen Chrystie  **Age:** 56  **Occupation:** Attorney  **Race/Ethnicity:** Greek father and Jewish mother. (That's why I don't look like anyone else.)  **Where Born:** Albany, New York  **Where Raised:** Brownwood, Texas, and Los Angeles, California  **Presently Reside:** Westwood Hills, California  **Relationship Status:** Married with two children  **Education:** UCLA and Harvard Law School  **Socio-Economic Class:** Lower Middle Class growing up  **Any Other Defining Characteristics or Experiences:** I have a nick name in the entertainment business, they call me the *man that keeps Hollywood honest*. I am a very aggressive and tenacious lawyer for my clients. I am also completely in love with my beautiful wife.  **Philosophical Statement:** I am a total optimist and therefore am virtually always in an *up* mood.

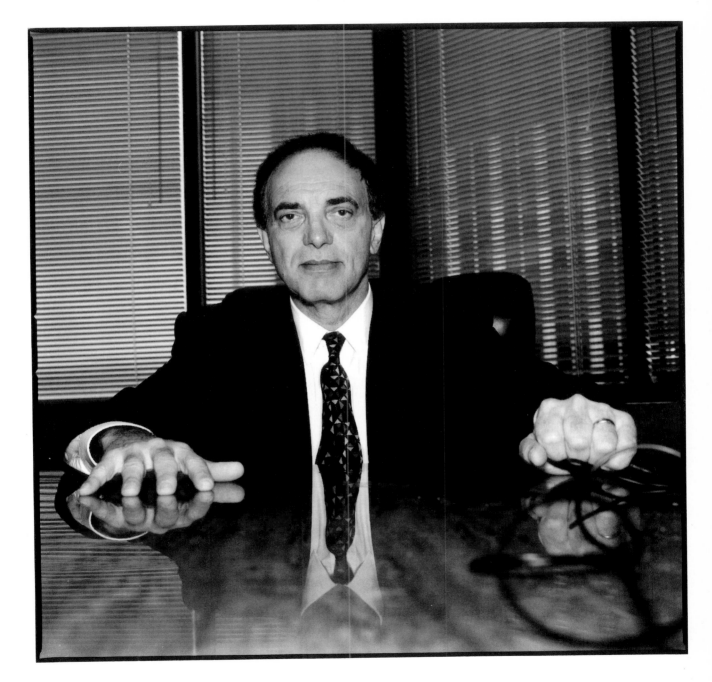

To Be A man You Have Want to Have
Job And want have A family and
Supart them and make sumting
Out your Life That Ai man.

*Name:* Henry Mims  *Age:* 48  *Occupation:* Heavy Equipment, Fuller Earth Mine  *Race/Ethnicity:* Black Man  *Where Born:* Decatur County, Georgia  *Where Raised:* Hanna Town, Georgia  *Presently Reside:* Hanna Town, Georgia  *Relationship Status:* Married  *Education:* Sixth Grade  *Socio-Economic Class:* Working Class  *Any Other Defining Characteristics or Experiences:* When I'm not working, I'm fishing. But I work all the time. I love to work. The only other thing I do is rest so that I can be ready for more work. *A man has got to work. If he ain't workin' he ain't a man.*  *Philosophical Statement:* I don't care about running around and drinking and playing.

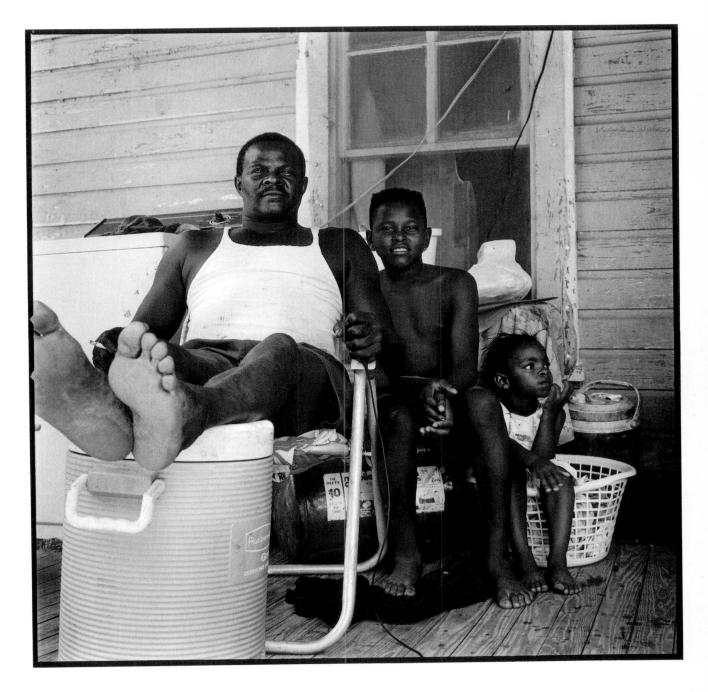

A MAN CAN SEE HIS DESTINY. A MAN
LIKES HANGING OUT WITH MEN AND WOMEN.
A MAN INCORPORATES HIS IDEAS INTO REALITY.
A MAN NEEDS TIME TO BE ALONE. A MAN
CRUISES AROUND IN SEARCH OF VENUS.
A MAN HAS FUN. AND, A MAN CAN TAKE
A JOKE.

**Name:** John Spence Stephens Jr.   **Age:** 24   **Occupation:** Singer/Dancer, UC Berkeley Inter-fraternity Council Public Relations Officer   **Race/Ethnicity:** White   **Where Born:** Fort Hood, Texas   **Where Raised:** Galveston, Texas; Boulder, Colorado; Santa Barbara, California   **Presently Reside:** Berkeley, Santa Barbara, and in my car on Highway 101   **Relationship Status:** Not Married   **Education:** Attended the U. of Colorado at Boulder, A.A. in Liberal Studies at Santa Barbara City College, B.A. in Dance and Music at UC Berkeley   **Socio-Economic Class:** High and Well-Off   **Any Other Defining Characteristics or Experiences:** As a son and brother, I have over 24 years of experience. A few years ago, a friend totaled my Corvette. I have also had some neat jobs—Lifeguard, doorman in bar, bank teller at drive-through, film-star, counselor, dancer, opera singer, *grunge* singer, six years college student, beach bum, total athlete, transient, random vampire, and turbo party machine. While at Cal, I founded the Phi Omega Tau Fraternity—Alpha, Alpha chapter. Some friends call me *Thumper*. And I love being in SUNSHINE!   **Philosophical Statement:** The Code of Phi Omega Tau: 1. Let people do what they need to do to find their path in life. 2. Always show a Phi Omega Tau the same respect I demand for myself. 3. Respect all men and women as I would a Phi Omega Tau. 4. Honor the Fraternity as a sacred and eternal bond of brotherhood and friendship. 5. Accept that all men and women are connected and respect our communicative bond. 6. Always pursue a light of understanding. 7. Dignifying my role on the planet, I am proud to stand as a Phi Omega Tau—yet in my world of love, it means nothing.

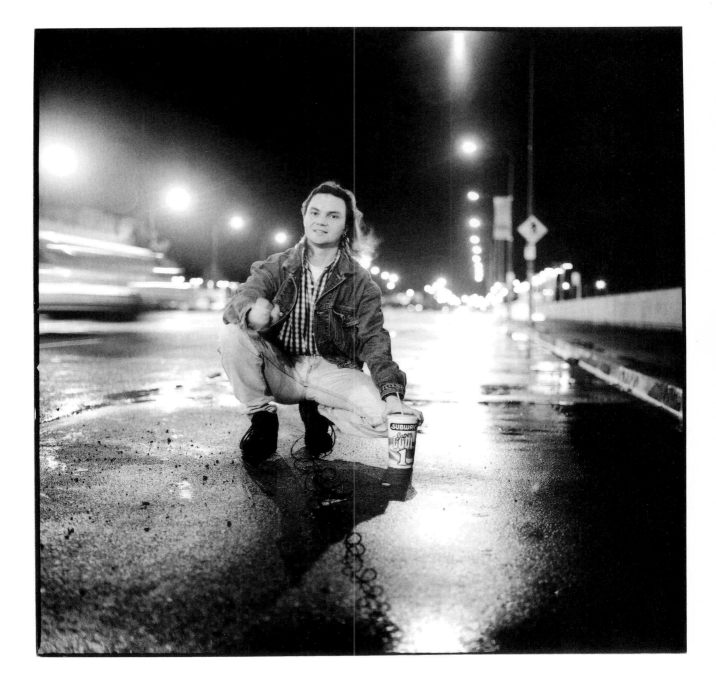

to be a man is to stand
tall, be not afraid to
roar, be not afraid to
cry.

*Name:* Al Lowman  *Age:* 45  *Occupation:* Literary Agent  *Race/Ethnicity:* WASP  *Where Born:* Harrisburg, Virginia
*Where Raised:* Virginia; Westchester, New York; London, England  *Presently Reside:* New York City  *Relationship Status:*
Divorced  *Education:* College Graduate—Romance Languages, B.A., M.B.A.  *Socio-Economic Class:* Upper Middle Class
*Any Other Defining Characteristics or Experiences:* —Alienated childhood and adolescence—Sixties sensibility: drugs, sex,
rock 'n roll, anti-war, blah, blah, blah  *Philosophical Statement:* Love is agreement.

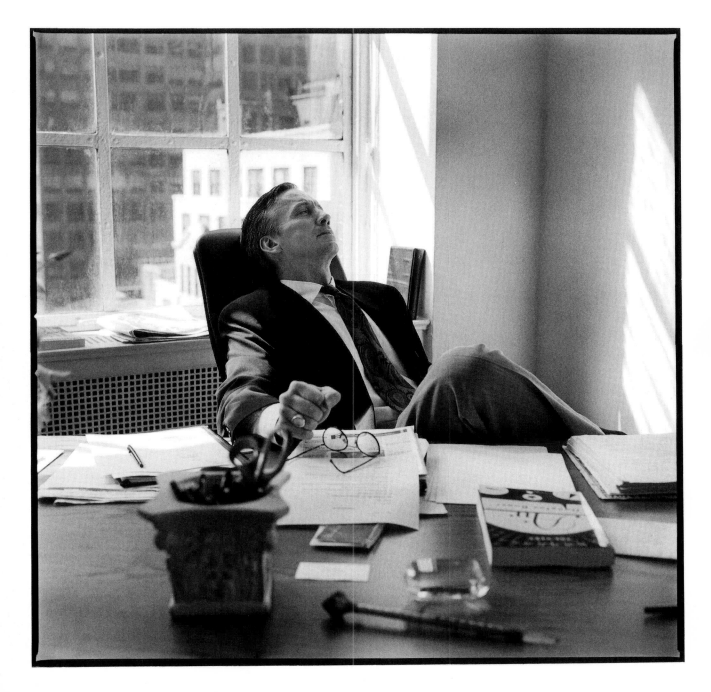

*A man is to be strong, tall, and have muscles in everything in the body. today is friday, june 19, 1992*

**Name:** Juan Mena   **Age:** 11 years old, born April 3, 1981   **Occupation:** Student   **Race/Ethnicity:** Mexican origin   **Where Born:** El Paso, Texas   **Where Raised:** El Paso, Texas   **Presently Reside:** El Paso, Texas   **Relationship Status:** Not married, I have a girlfriend.   **Education:** I want to be an Immigration Officer.   **Socio-Economic Class:** Middle   **Any Other Defining Characteristics or Experiences:** I am skinny.   **Philosophical Statement:** I play sports.

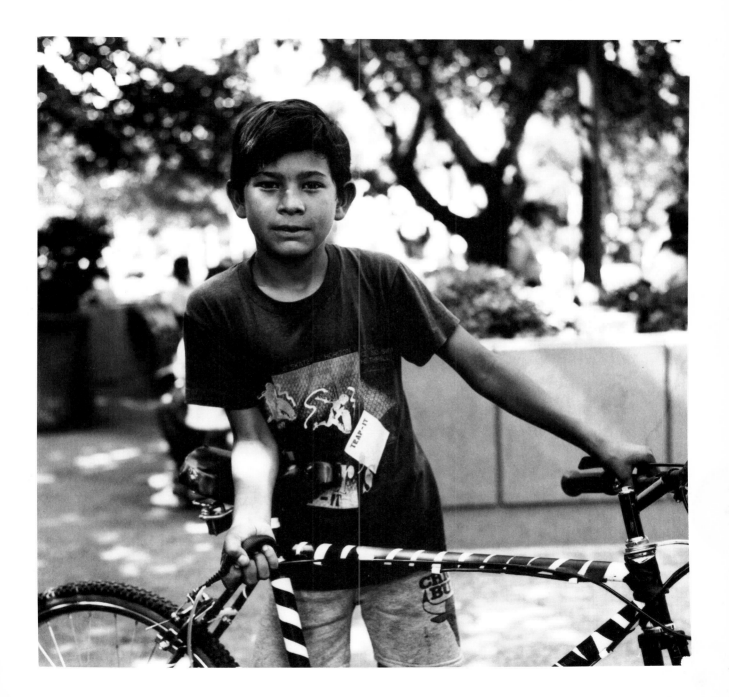

*Every man is different. We all can't be the same. Being an individual is what life is about. So if your happy with yourself, you are being the man you want to be*

*Brad Whitfield*

**Name:** Brad Whitfield  **Age:** 34 years  **Occupation:** Cowboy  **Race/Ethnicity:** German father, American mother  **Where Born:** Midland, Texas  **Where Raised:** Odessa, Texas  **Presently Reside:** Fort Davis, Texas  **Relationship Status:** Married, three children  **Education:** High school graduate  **Socio-Economic Class:** Working Class  **Any Other Defining Characteristics or Experiences:** Been a cow puncher all my life.  **Philosophical Statement:** Live each day to the fullest because you don't know when the last day is. Here today, gone tomorrow.

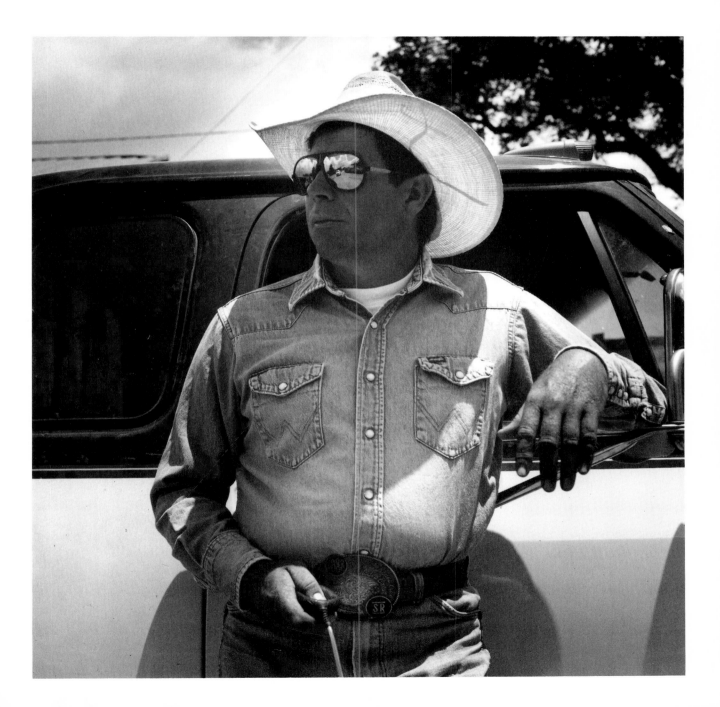

In China, A man is more responsibility to his wife, Children and parents, even when he is not love his wife anymore, he is still responsibility to his family and did not divorce, so that in China the family is very stable.

*Name:* Linbai Ye *Age:* 46 *Occupation:* Professor *Race/Ethnicity:* Chinese *Where Born:* Guangdong, China *Where Raised:* Guangdong, China *Presently Reside:* North Carolina, USA *Relationship Status:* Married *Education:* Graduate Student—Ph.D. *Socio-Economic Class:* Middle *Any Other Defining Characteristics or Experiences:* I like science, but I also like all kinds of sports, even fishing and hunting. I have one child. *Philosophical Statement:* A boy becomes a man when he gets married.

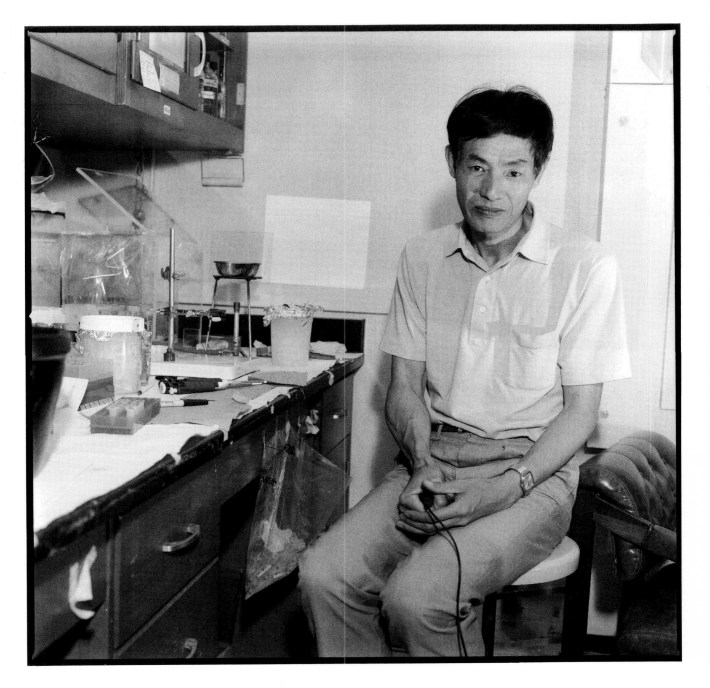

I don't believe one should be asked to say what it means to be a man — it should be what does it mean to be a human being — the Jews have a word for it." you must first be a <u>mensch</u>.! Good or bad great or wonderful or ugly or beautiful — honest — courageous are not virtues — or vices that are restricted to one gender. A Real man understands and recognizes this and then lives his his life accordingly. Everyday one must say to day I am a man — mensch!

**Name:** Harry E. Weiss  **Age:** 75  **Occupation:** Attorney  **Race/Ethnicity:** White—Jewish  **Where Born:** Chicago  **Where Raised:** Chicago & L.A.  **Presently Reside:** L.A.  **Relationship Status:** Single  **Education:** College & Law School  **Socio-Economic Class:** People have me in all kinds of classifications  **Any Other Defining Characteristics or Experiences:** Actor—Teacher—Vaudevillian—Attorney  **Philosophical Statement:** Be good to yourself, because when you are good to yourself and appreciate yourself, only then can you be good and appreciate the world.

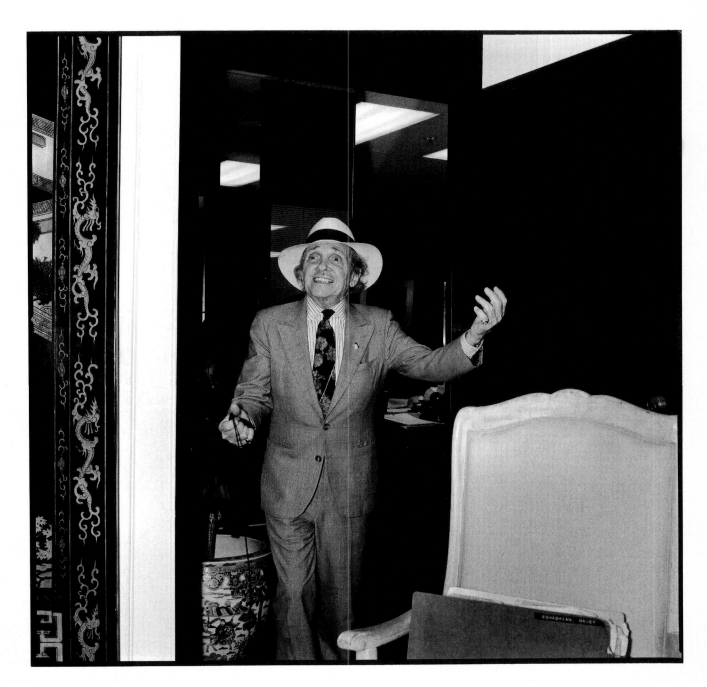

Being a man is to confront paradoxical experiences with a contradiction. But it is also to know the freedom and the responsibility that comes with the destruction of social stereotypes.

**Name:** John Shosky and Austin   **Age:** 37   **Occupation:** Speechwriter & Adjunct Professor of Philosophy, American University   **Race/Ethnicity:** White   **Where Born:** Colorado Springs, Colorado   **Where Raised:** Pueblo, Colorado   **Presently Reside:** Alexandria, Virginia   **Relationship Status:** Single   **Education:** B.A. Colorado College, M.A. U. of Wyoming, Ph.D. American University   **Socio-Economic Class:** Middle Class   **Any Other Defining Characteristics or Experiences:** A life changer—reading Peter Mathiessen's *Snow Leopard*   **Philosophical Statement:** We have the freedom to dream and the opportunity to realize the possible.

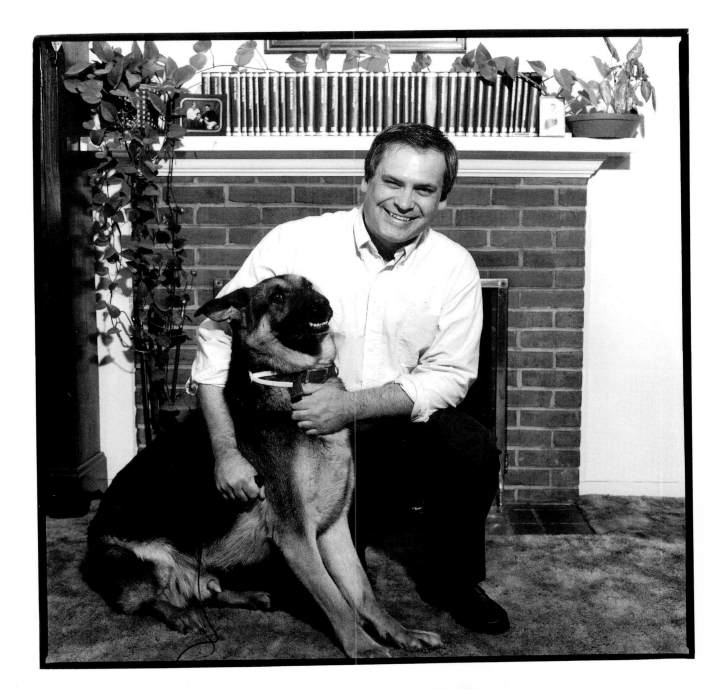

Beeing a man. a man makes himself But it takes
To two Tings a man Cant live With out a Waman
and a woman. cont live Without a man a man is the horse
and a waman trees to be the boss. but the man says
no way the Waman Wants the money no money no Honey

*Name:* Vinnie Gaudino  *Age:* 60  *Occupation:* Street Vendor/Peddler/Frank-Man  *Race/Ethnicity:* Italian  *Where Born:* Brooklyn, New York  *Where Raised:* Brooklyn, New York  *Presently Reside:* Brooklyn, New York  *Relationship Status:* Married with four kids  *Education:* Don't have none, I'm a street peddler.  *Socio-Economic Class:* Middle  *Any Other Defining Characteristics or Experiences:* I'm a Catholic; I'm a Brooklyn boy; I'm a street peddler. What else is there to know? I raised a family and worked the same corner for 29 years.  *Philosophical Statement:* I believe in God; I go to church every Sunday. I don't smoke, and I don't drink.

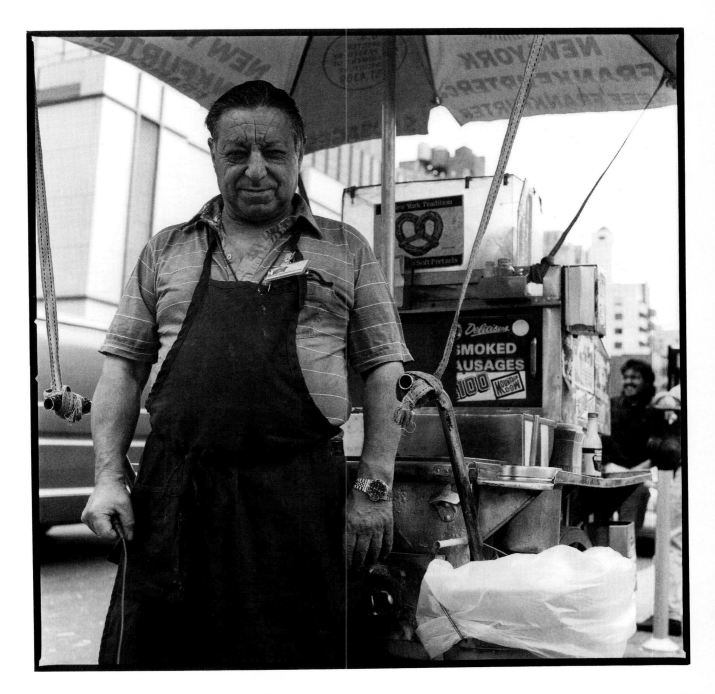

Being a man is accepting life's responsibilities and solving life's problems because no one else is going to solve them for you.

Every man should be affiliated with a church and I was brought up to honor a woman.

*Charles L. Peckham*

*Name:* Charles L. Peckham  *Age:* 87  *Occupation:* Dairy Farmer  *Race/Ethnicity:* Pure Bred Yankee (my family came over in 1630)  *Where Born:* East Woodstock, Connecticut  *Where Raised:* East Woodstock, Connecticut  *Presently Reside:* Dudley, Massachusetts (the same house since 1932)  *Relationship Status:* Married (the same woman for 62 years), I have three boys.  *Education:* High School graduate  *Socio-Economic Class:* Middle Class—didn't have a lot of money, but had the things that were necessary.  *Any Other Defining Characteristics or Experiences:* I never got into politics, but I served as deputy fire-warden. I had a grain business for 35 years. I have been a member of the *Grange* for seventy years, and joined all the degrees right through the seventh degree. I also have Parkinson's Disease.  *Philosophical Statement:* I always tried to do whatever I could to make things better for my family and the community.

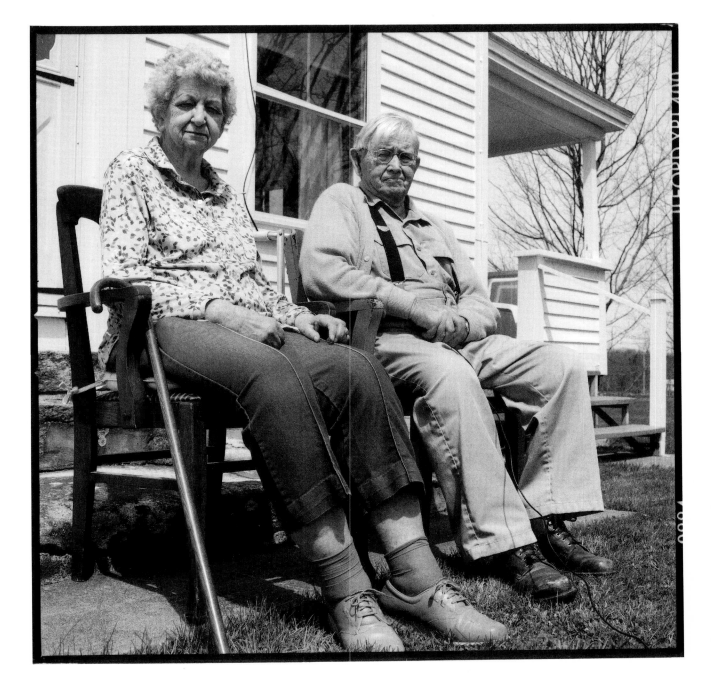

Being A Man is being true to My homeboys and dealing with the police and being around drugs

*Name:* Donnell White  *Age:* 28  *Occupation:* None  *Race/Ethnicity:* Black  *Where Born:* L.A., California  *Where Raised:* Compton, California  *Presently Reside:* Compton, California  *Relationship Status:* Married  *Education:* Compton—High School  *Socio-Economic Class:* Poor  *Any Other Defining Characteristics or Experiences:* Member of the Compton Crips (L.A. gang).  *Philosophical Statement:* Bettering Myself

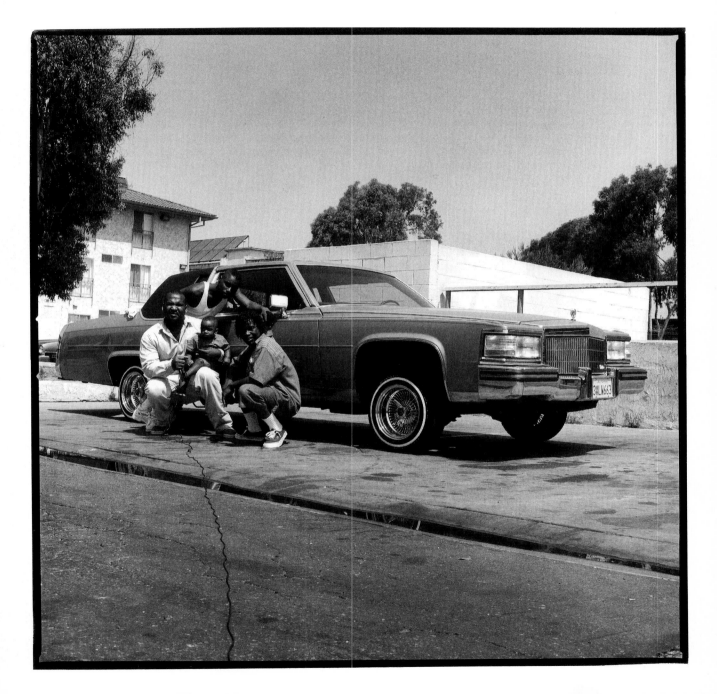

Do what you want - say what you think
and back it up. R.E.M. 4/28/93

**Name:** Roland McLaughlin **Age:** 70 **Occupation:** Retired Lumber-man **Race/Ethnicity:** White **Where Born:** Medway, Maine **Where Raised:** Medway, Maine **Presently Reside:** Medway, Maine **Relationship Status:** Married to the same woman for 47 years. I have 5 children and 13 grand-kids. **Education:** 12 years; finished high-school. **Socio-Economic Class:** We were all poor back then, but we didn't know we were poor. **Any Other Defining Characteristics or Experiences:** Youngest boy, so naturally I had to be a fighter. Also a World War II veteran, in US Marine Corp. **Philosophical Statement:** Do what is right; hurt no man that doesn't hurt you; and love your maker . . . and you'll get by alright.

44

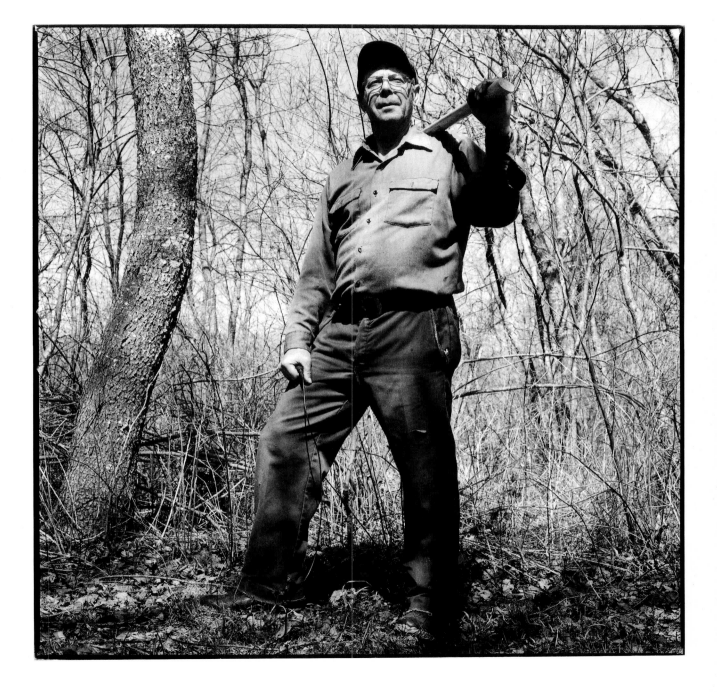

Its not about being a man or a woman its what we can do for our kids. Its not fun to get up before daylight at -20°, and chop wood, or go out fishing in a gale of wind, but if thats what keeps the lights on and the shelves full than thats what you do.

I think men and women both lose perspective. Mutual respect for each other, be they male or female, or black or white or red ... thats the answer. that and respect for mother Earth. the lack of that respect is the real problem with this world.

*Name:* Ted McLaughlin  *Age:* 39  *Occupation:* Fisherman  *Race/Ethnicity:* Irish/Indian  *Where Born:* Lincoln, Maine
*Where Raised:* salmon stream!  *Presently Reside:* Port Clyde, Maine  *Relationship Status:* Married  *Education:* CS BS DD
*Socio-Economic Class:* Red Neck / Indian / hard working SOB  *Any Other Defining Characteristics or Experiences:* Lobster
fisherman / Tuna fisherman. I am proud to be a fisherman! If it swims, and it's legal, I'm after it . . . for my kids.
*Philosophical Statement:* I ain't much of a philosopher.

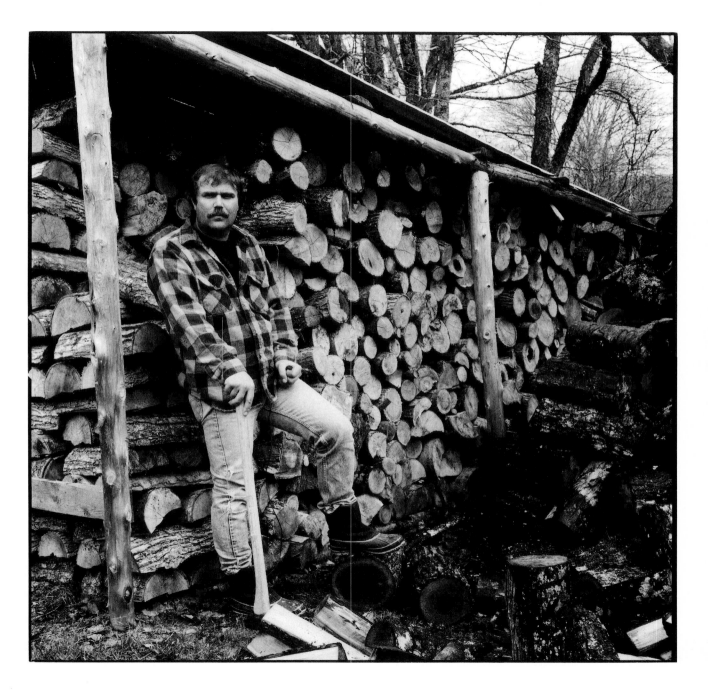

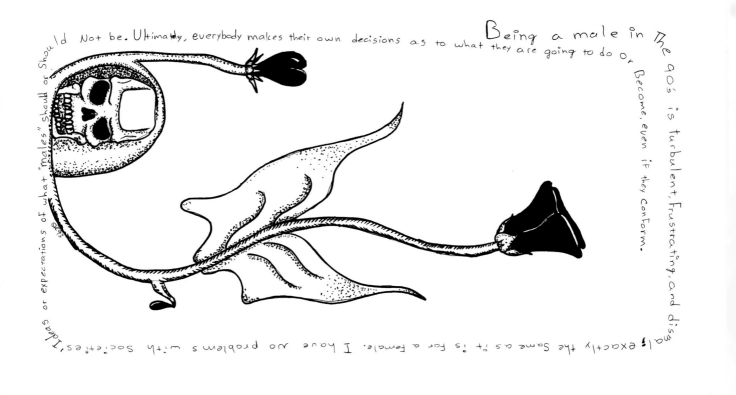

ld Not be. Ultimately, everybody makes their own decisions as to what Being a male in The 90's is turbulent, frustrating, and disappointing. Ideas or expectations of what "males" should or should they are going to do or Become, even if they conform. exactly the same as it is for a female. I have no problems with Societies.

**Name:** Scott Kimberley   **Age:** 22   **Occupation:** Student/Life   **Race/Ethnicity:** I don't know.   **Where Born:** Ventura, California   **Where Raised:** Ventura, California   **Presently Reside:** Canoga Park, California   **Relationship Status:** Single but taken   **Education:** High School, some college   **Socio-Economic Class:** Human . . . no, really, Dirt Poor   **Any Other Defining Characteristics or Experiences:** Love snow skiing and flying, screwing with people's minds, tattoos and body piercing. I love it!   **Philosophical Statement:** My philosophy . . . changes constantly, but in its most basic form is to simply take in and experience as much as possible, all the time, and keep an open mind.

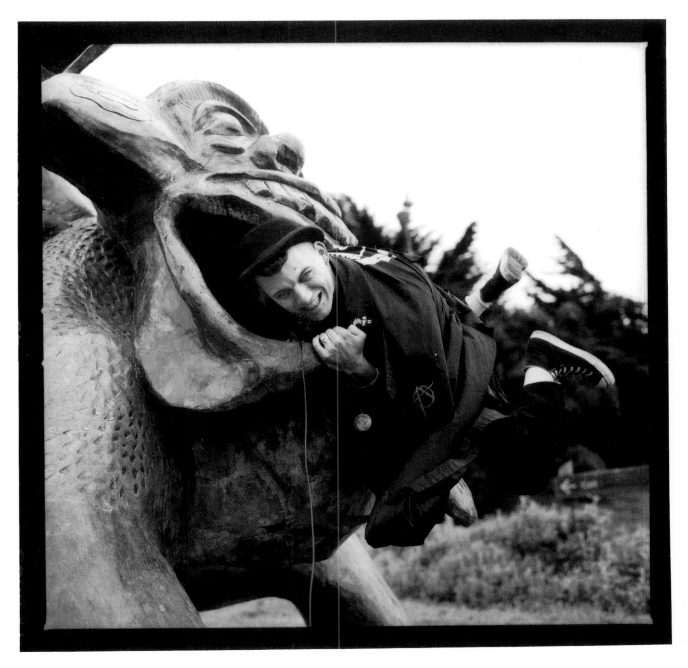

A man To Be Successful in my opinion. IS ThaT he must Be mentally Independant. enough To make his own Decisions. Find a lover with whom he is aTTracTed To & has SuperB communication. maybe a wife & family. I DonT Know. a Regular program of exercise. An arTistic Sense And great Diversity, and eTc

*Name:* Raj Brandstein   *Age:* 32 years   *Occupation:* Chef and Restaurant Owner   *Race/Ethnicity:* Half East-Indian, and half Jewish   *Where Born:* Forest Hills Hospital   *Where Raised:* Queens and Manhattan, New York   *Presently Reside:* Venice Beach, California   *Relationship Status:* Single   *Education:* College, Culinary Institute of America, Associate of Occupational Studies and Apprenticeship   *Socio-Economic Class:* I come from Upper Middle Class.   *Any Other Defining Characteristics or Experiences:* My mother committed suicide when I was fifteen. My mother got divorced when I was six months old and again when I was eight years old.   *Philosophical Statement:* I'm on the path to finding the true meaning of THE WAY through the discipline of karate.

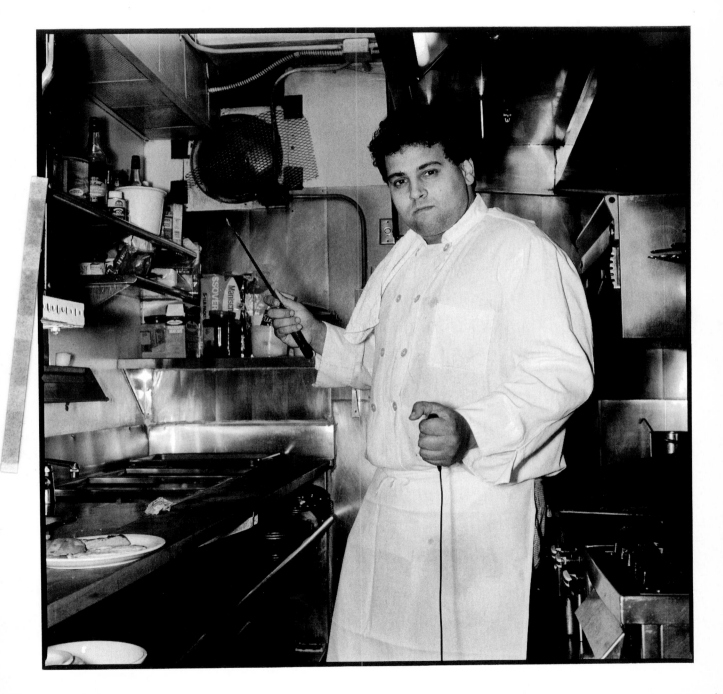

TO BE
GENEORUS (most) Sometimes
AND
Stingy Others

ETC

*Name:* Bob Clark   *Age:* 28 years   *Occupation:* What the hell? Pawn shop manager / Retail manager / Loan Representative
*Race/Ethnicity:* half Mohawk Indian, half Scottish   *Where Born:* Elmira, New York   *Where Raised:* Institutions   *Presently*
*Reside:* Seattle, Washington   *Relationship Status:* Not married, but have a wife and two kids.   *Education:* High School drop-
out   *Socio-Economic Class:* Middle Class now, before was real poor   *Any Other Defining Characteristics or Experiences:*
Trying to do everything   *Philosophical Statement:* Live one day at a time, don't live tomorrow, don't live yesterday, just
live today.

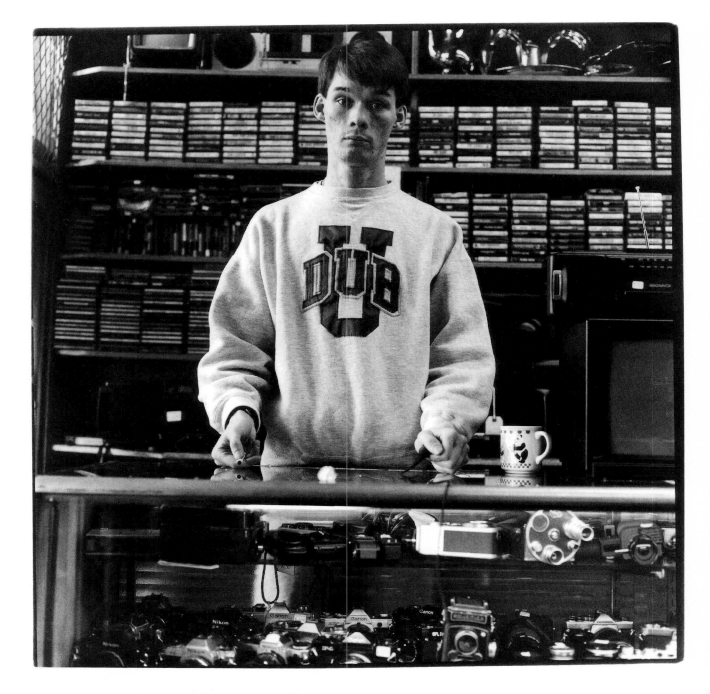

*Para Ser hombre importante es para mi , Cumplir Con las Obligaciones en el trabajo y con mi familia y estar bien Con las leyes del gobierno.*

**TRANSLATION:** To be a man it is important for me, to fulfill my obligation at work and with my family and to be all right with the laws of the government.

**Name:** Antonio Mata   **Age:** 27 years   **Occupation:** Work with a hoe   **Race/Ethnicity:** Hispanic   **Where Born:** Querétaro, Mexico   **Where Raised:** Querétaro, Mexico   **Presently Reside:** Hollister, California   **Relationship Status:** Married, two children   **Education:** Secondary school to 12 years old   **Socio-Economic Class:** Poor   **Philosophical Statement:** Meet my responsibilities with work and stay within the law.

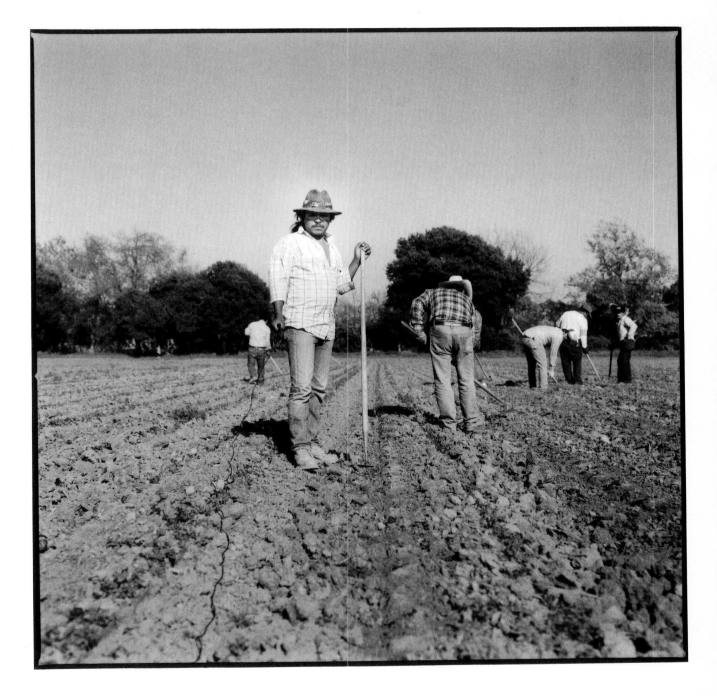

the diference between a man and a woman is a man can
do what he wants when he wants and a woman always cant.
because of what she is.

*Name:* Kristian Kenneth Cox   *Age:* 18   *Occupation:* Full time Guardian Angel   *Race/Ethnicity:* Caucasian   *Where Born:* Toronto, Canada   *Where Raised:* Toronto, Canada   *Presently Reside:* Live in the Guardian Angels H.Q., N.Y.   *Relationship Status:* Single, a full time Guardian Angel   *Education:* 11th grade   *Socio-Economic Class:* Normal white kid, but I lived in the projects in Regent Park, Toronto.   *Any Other Defining Characteristics or Experiences:* In Canada I used to work at bars. I joined the football team, but I found it boring.   *Philosophical Statement:* Life; you're not here for all that long so do it while you have the chance.

Tradionally, the man is the breadwinner — but Today, everyone is a breadwinner. Therefore, to be a man is to be the emotional support & strength behind a family. His strength balances the woman's gentleness. A man is firm — a woman is soft.

*E. L. S.*

**Name:** Edward Lincoln Shugrue III  **Age:** 27  **Occupation:** Banking  **Race/Ethnicity:** White-Bread Protestant  **Where Born:** Boston, Massachusetts  **Where Raised:** Milton, Massachusetts  **Presently Reside:** New York City  **Relationship Status:** Married  **Education:** Honors degree—Political Science—U. of Penn. Milton Academy—University of Edinburgh  **Socio-Economic Class:** Middle Class (Plenty of Style; Socio-Economic Background, questionable).  **Any Other Defining Characteristics or Experiences:** My wife Greta . . . Cuban Cigars . . . A quiet day fly-fishing  **Philosophical Statement:** Jah Rastafari.

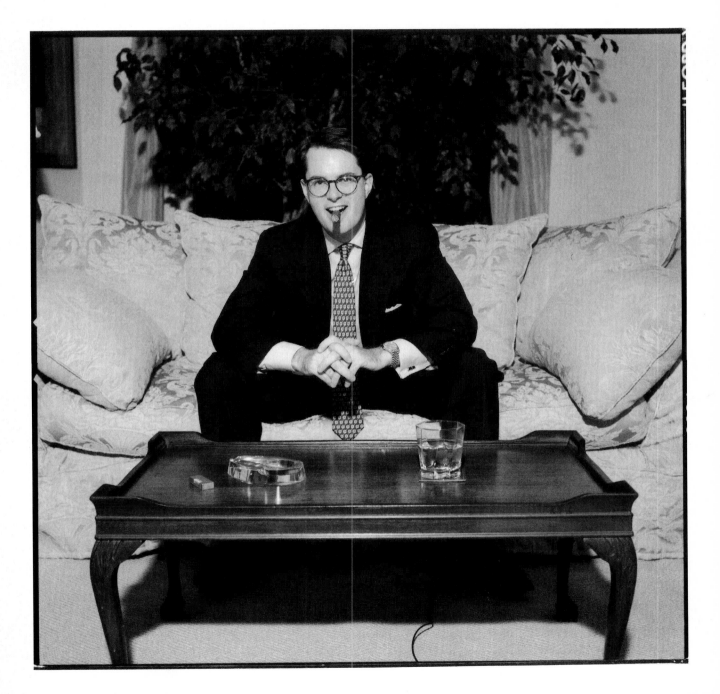

*Try to bring happyness to other and most thing will solve themselps.*

---

**Name:** Charles (Jolly) O'Leary  **Age:** 72  **Occupation:** Road Supt.  **Race/Ethnicity:** Irish White—C.I.A. (Catholic-Irish-Alcoholic)  **Where Born:** Malden, Massachusetts  **Where Raised:** Malden, Massachusetts  **Presently Reside:** Gloucester, Massachusetts  **Relationship Status:** Third Marriage, raised 13 children.  **Education:** 10th grade  **Socio-Economic Class:** Working middle class. Whatever I made, I got from the sweat off my ass.  **Any Other Defining Characteristics or Experiences:** I never kept a job that I was not happy doing.  **Philosophical Statement:** I have no fears about dying because *I did it my way!*

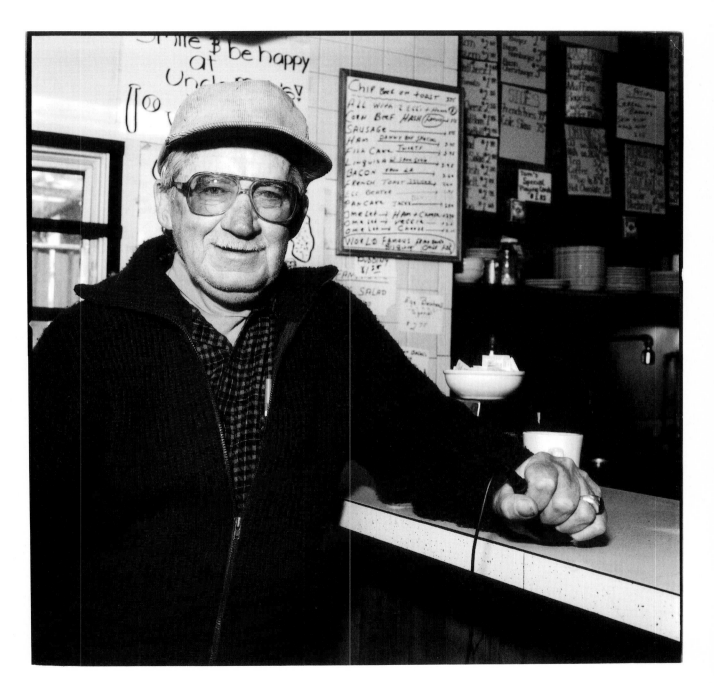

*The world exists to be Eaten and Fucked by ME and ME ALONE!!*

**Name:** Ben Chesluk   **Age:** 21   **Occupation:** Student   **Race/Ethnicity:** Yes   **Where Born:** Denver, Colorado   **Where Raised:** Santa Cruz, California   **Presently Reside:** Berkeley, California   **Relationship Status:** Single   **Education:** UC Berkeley   **Socio-Economic Class:** Middle, I suppose.   **Any Other Defining Characteristics or Experiences:** I study anthropology and folklore and listen to the blues. I hate cars and advertising.   **Philosophical Statement:** Life is short, but wide.

62

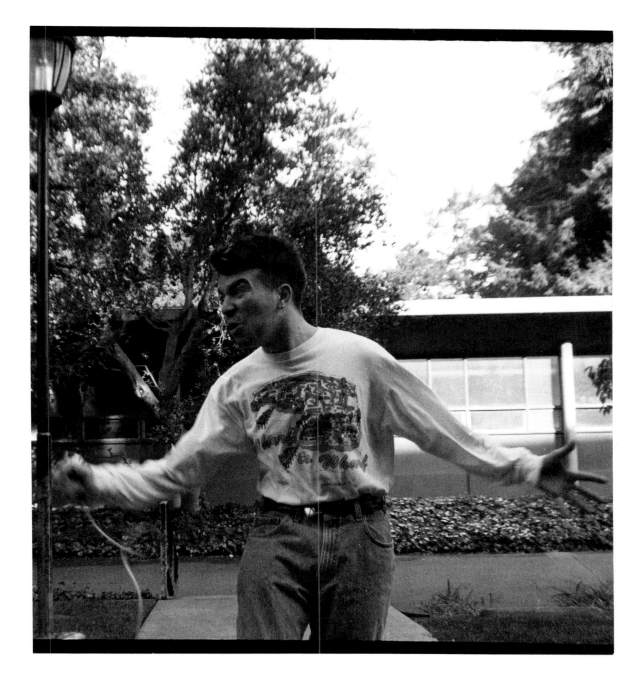

*Being a man in our modern, rapidly changing world necessitates embracing those qualities formerly reserved for women: deep caring for the plight of others, protectiveness towards the environment, and abhorrence of violence in any form. In other words, we must put our destructive past behind us and begin doing what we can to make this fragile planet of ours a safer, healthier, more humane place before it is too late.*

*— Bob Kevess MD*

**Name:** Bob Kevess  **Age:** 34 years  **Occupation:** Family Physician  **Race/Ethnicity:** Caucasian  **Where Born:** Brooklyn, New York  **Where Raised:** Brooklyn, New York  **Presently Reside:** Oakland, California  **Relationship Status:** Single  **Education:** B.A.: Brandeis University, Massachusetts. M.D.: NYU, New York  **Socio-Economic Class:** Middle Class  **Any Other Defining Characteristics or Experiences:** I grew up in a left-wing Jewish family in New York City. My father was passionately political and so am I. Like he did, I care deeply about the plight of the downtrodden. As a proud gay man, I am particularly concerned with discrimination against sexual minorities, and I am active in the struggle against this pernicious still acceptable form of bigotry.  **Philosophical Statement:** Make it your first priority in life to reach a state of self acceptance and contentment, then go out into the world and help others do the same. This is the key to happiness.

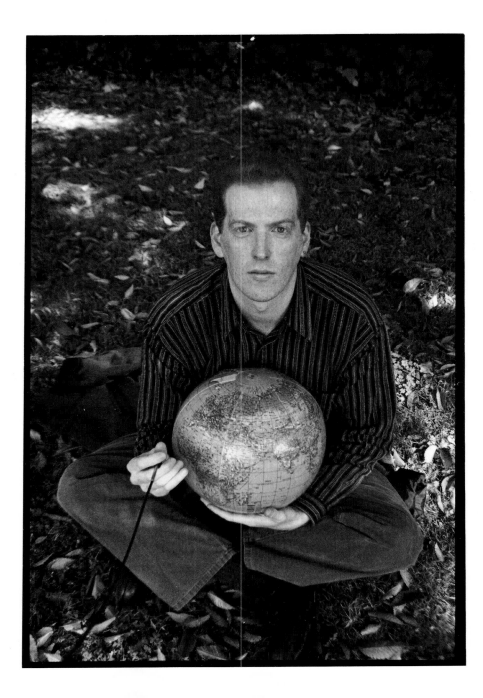

*I think the definition of a man is ever-evolving, everchanging. As we progress and understand ourselves better the definition changes*

*I believe a man is not afraid to take chances. We are unable to make strides without taking risk. A man is able to adapt, to change and to overcome obstacles. One cannot grow by being obstinate and unyielding. A man is someone who can lead by example, not only by words.... My definition of a man is some one that "Plants his feets, take a stand... and kick some ass!"* Reginald Hunter

**Name:** Reginald L. Hunter   **Age:** 25   **Occupation:** Producers Assistant   **Race/Ethnicity:** Black   **Where Born:** New York, New York   **Where Raised:** Los Angeles, California   **Presently Reside:** A quaint, quiet, little planet called Earth.   **Relationship Status:** Single   **Education:** San Diego State / U.C.L.A.   **Socio-Economic Class:** Surviving and striving for more.   **Any Other Defining Characteristics or Experiences:** Circumcised   **Philosophical Statement:** Create your own vibe.

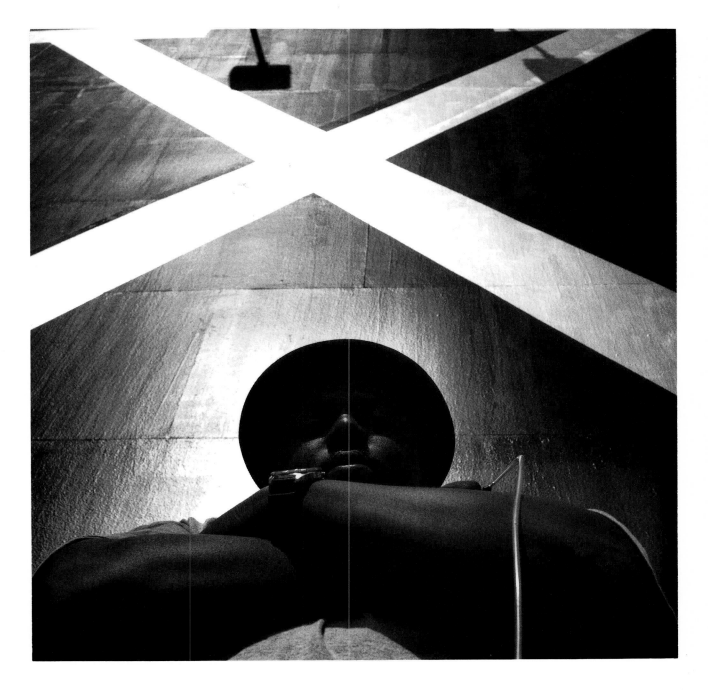

*Even if women stay awny from macho and Dominating men, in reality that's what impresses them.*

**Name:** Pierre Moeini    **Age:** 29 years    **Occupation:** Manage Car Dealership, Top-Less Auto    **Race/Ethnicity:** Persian    **Where Born:** Teheran, Iran    **Where Raised:** Teheran, Iran; and Paris, France    **Presently Reside:** Los Angeles, California    **Relationship Status:** Married    **Education:** College, studying French Civilization. I had a French education.    **Socio-Economic Class:** When I was back home (Teheran) I was upper class. When I was in France, I was middle class, because I was on my own. **Any Other Defining Characteristics or Experiences:** I have lived in four countries starting from nothing every time I moved. I had to learn new cultures and new languages at each place.    **Philosophical Statement:** Never give up, it makes everything easy because you know that you are going to reach the end.

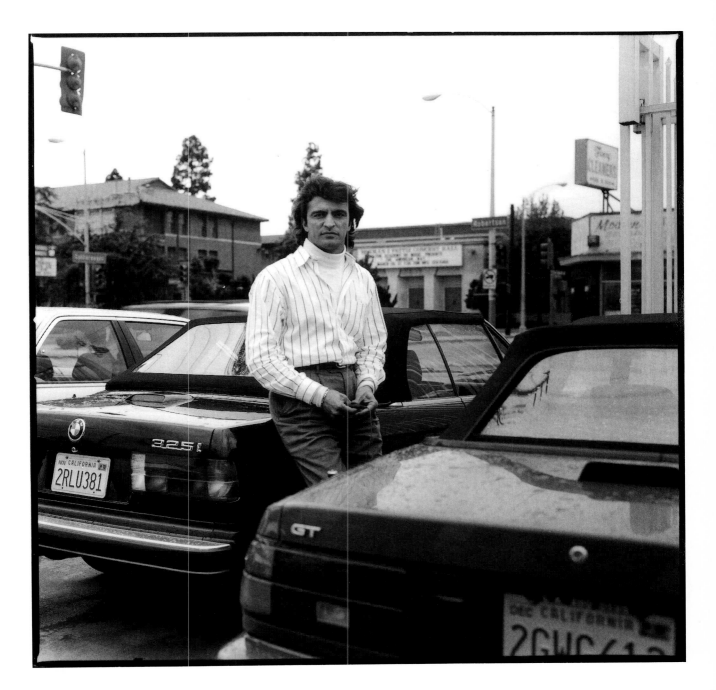

Being a Man is:
Sexual, Inner Satisfying, Hard, physically strong! I expected on whatever way I want women & Men to see me & Respect me

Viva

**Name:** Viva  **Age:** Old enough  **Occupation:** Entertainer  **Race/Ethnicity:** Spanish/German  **Where Born:** Orange County, California  **Where Raised:** Los Angeles, California  **Presently Reside:** Monterey Park, California  **Relationship Status:** Safely dating  **Education:** High School  **Socio-Economic Class:** Middle Class, now I'm better than that.  **Any Other Defining Characteristics or Experiences:** I am gay, but I think women are beautiful. I have a lot of respect for women and I don't think as highly of men. I'm a lesbian trapped in a homosexual's body . . . or maybe I'm a straight woman trapped in a man's body? **Philosophical Statement:** I want to be happy and see my art accepted. I have a lot of hatred toward the criminal element in this world which has made me ashamed of my own race and sexuality. I hope one day things will be different.

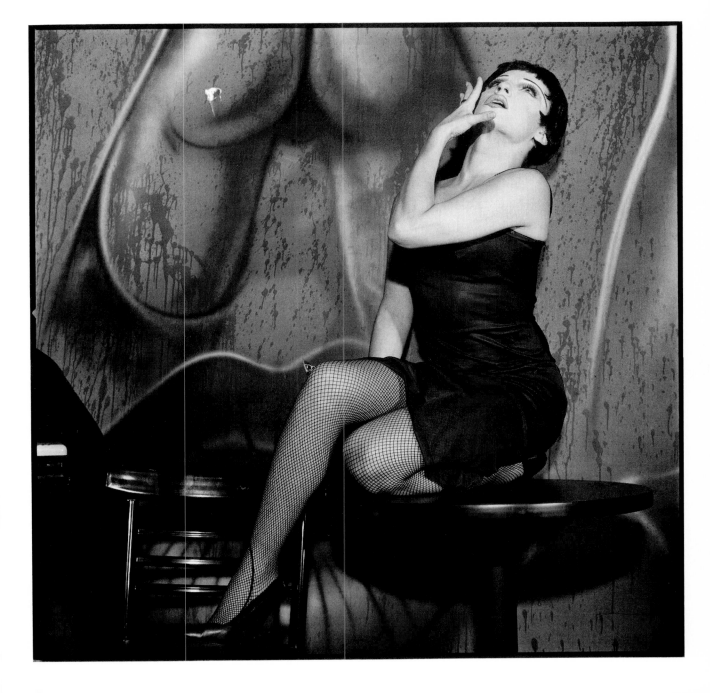

*Being a man is knowing and having the proper respect for women, is knowing that as a man we can never be a mother so we compensate by trying to be a better father, not by vacating our responsibilities as parents but instilling in our offspring the respect for law and order and the rights of persons.*

**Name:** Major M. Meador    **Age:** 69 (70 next week)    **Occupation:** Retired (Corporate Manager, presently Recorder of Kerbela Shriners Temple)    **Race/Ethnicity:** White Male    **Where Born:** Galen, Tennessee    **Where Raised:** Nashville, Tennessee (Old Hickory)    **Presently Reside:** Knoxville, Tennessee    **Relationship Status:** Married    **Education:** Post-College Grad. (Law School)    **Socio-Economic Class:** Farm    **Any Other Defining Characteristics or Experiences:** Born and Raised on a Tennessee Farm. W.W.II Veteran, Submarine. (Shriner for 35 years, Honorary Colonel twice over)    **Philosophical Statement:** I have always had the pleasure of doing work that I enjoyed. One of the greater pleasures is the meeting of people in (from) all walks of life.

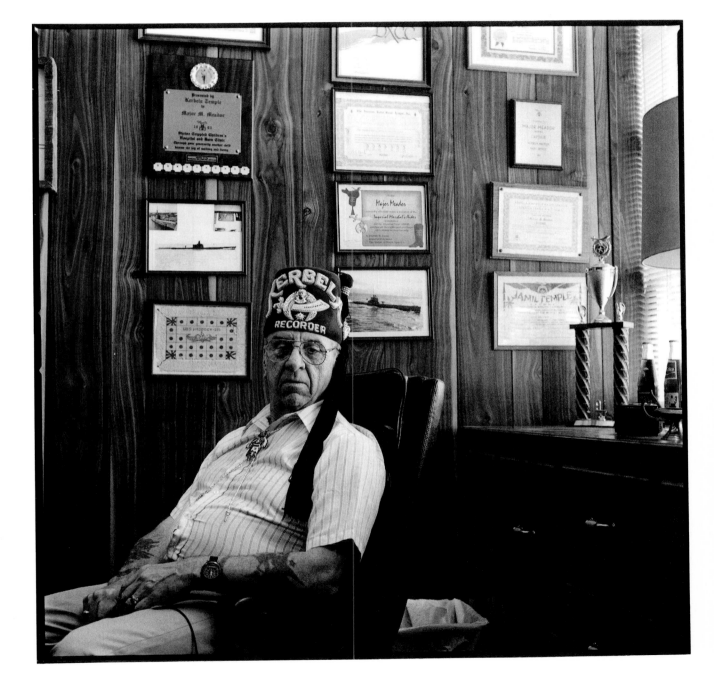

WOMEN HAVE HALF OF the MONEY

and aLL tHe PUSSY

We AINT GOT A Chance

*Name:* Charlie Johnson   *Age:* 46   *Occupation:* Janitor   *Race/Ethnicity:* White   *Where Born:* London, Ohio   *Where Raised:* London, Ohio   *Presently Reside:* London, Ohio   *Relationship Status:* M   *Education:* 12   *Socio-Economic Class:* Hi Class *Any Other Defining Characteristics or Experiences:* Harley Rider   *Philosophical Statement:* Ride to Live—Live to Ride.

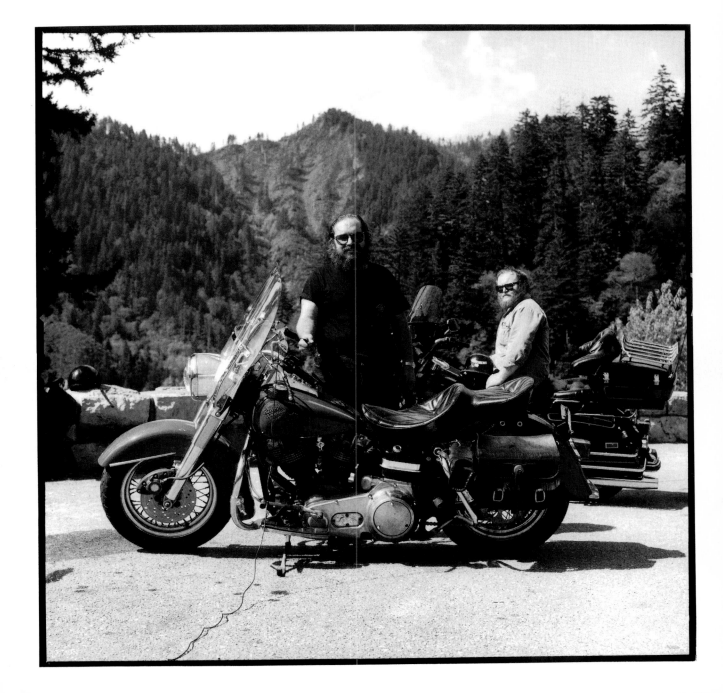

*BEING A MAN IS*
*NOT BEING AFRAID*
*TO EXPERIENCE*
*YOUR FEMININE SIDE.*

*Bob Hayes '95*

**Name:** Bob Hayes   **Age:** 38   **Occupation:** Cinematographer   **Race/Ethnicity:** Human   **Where Born:** Los Angeles, California **Where Raised:** Sherman Oaks, California   **Presently Reside:** Santa Monica, California   **Relationship Status:** Single   **Education:** Still learning; nature has always been my teacher.   **Socio-Economic Class:** Middle   **Any Other Defining Characteristics or Experiences:** To have lived.   **Philosophical Statement:** As you see it, so it will become.

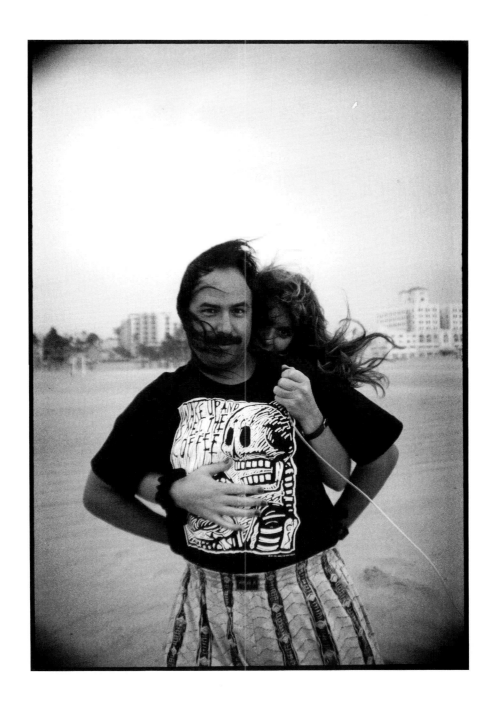

*It's better than being a woman!*

*Being a man, to me, means being in control of my life... sometimes of other people's lives.*

---

**Name:** Don Thompson  **Age:** 57  **Occupation:** Musician  **Race/Ethnicity:** English—for the last 1000 years  **Where Born:** Kendal, England  **Where Raised:** Kendal, England  **Presently Reside:** San Francisco, California  **Relationship Status:** Single  **Education:** M.A. Cambridge University; Ph.D. Oxford University  **Socio-Economic Class:** I would never clarify it. I have champagne tastes and a lemonade income.  **Any Other Defining Characteristics or Experiences:** Music, Leather, Sex. Intellectual  **Philosophical Statement:** It can't get any worse.

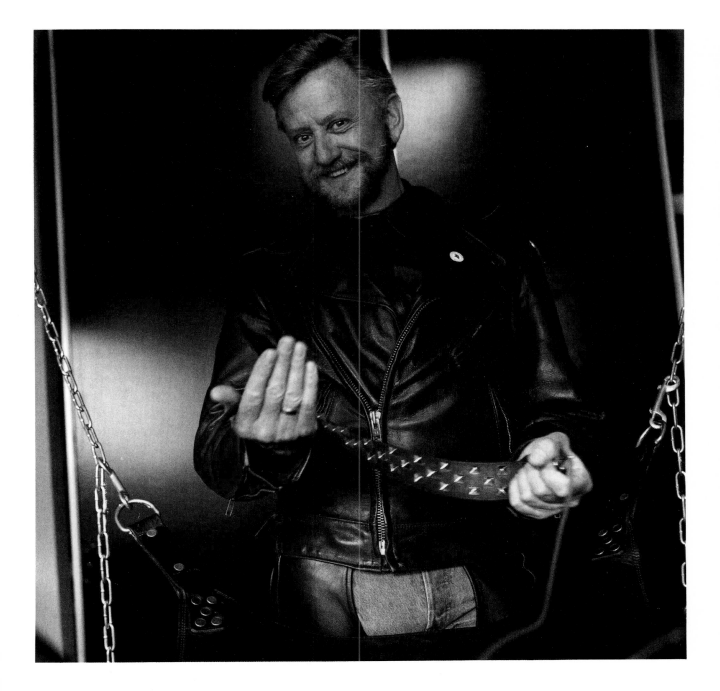

*Being a man means being at ease with one's history and situation in the world. It means replacing the myths and illusions of society and culture with faith in a personal vision. It means openness to emotion, to the senses and the cues of fate. It means gentle humor leavened with a dash of erotic darkness. It means the expansiveness of attitude that comes from strength and the responsibility to others live strong that strength implies.*

*Terence McKenna*

**Name:** Terence McKenna   **Age:** 47   **Occupation:** Writer   **Race/Ethnicity:** 25% Sicilian, 50% Irish, 25% Welsh, English   **Where Born:** Paonia, Colorado   **Where Raised:** Paonia, Colorado, and California   **Presently Reside:** Occidental, California   **Relationship Status:** Getting Divorced.   **Education:** B.S., U.C. Berkeley   **Socio-Economic Class:** From a seemingly rich family in a very poor county. Upper middle class in a place where you don't get any higher.   **Any Other Defining Characteristics or Experiences:** Being raised Catholic in a lily white town—completely homogeneous folk—so the prevailing social issue of the time never was an issue growing up. My most defining experiences were my trip to the Amazons in 1971 with my brother and my years in Berkeley from 1965 to 1967.   **Philosophical Statement:** Don't believe in anything!

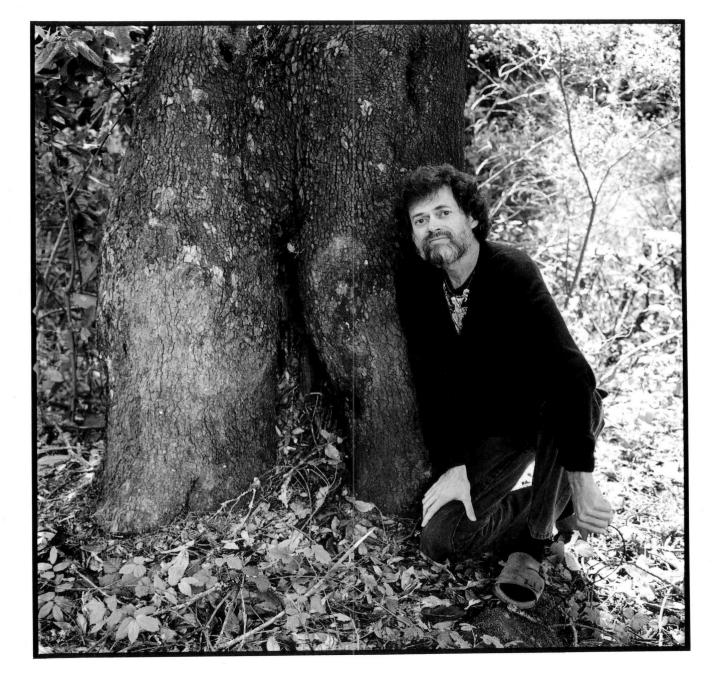

*Money & Job.*

**Name:** Daniel S. McGregor  **Age:** 29  **Occupation:** Marine Engineer  **Race/Ethnicity:** Caucasian  **Where Born:** Panama
**Where Raised:** San Rafael, California  **Presently Reside:** Reno, Nevada  **Relationship Status:** Single  **Education:** Tech. School
**Socio-Economic Class:** Middle class  **Any Other Defining Characteristics or Experiences:** I'm a nice guy, so I finish last.
**Philosophical Statement:** Get a job.

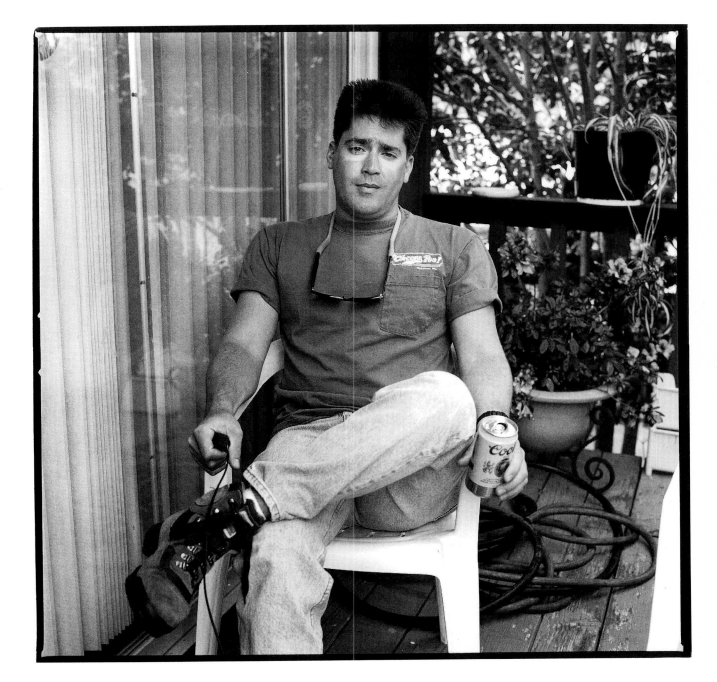

What is it to be a man? So many answers. As my life has progressed I have understood what it is to be a son, a brother, a student, a friend, a lover and now a father. Overshadowing all these is that ever-present pressure of being a man, an African-American man in the world. To _simplify_ is the best way to find the man that I want and need to be. Not that less is more but just _BEING_ is the best that I can do. And I like it a lot — being a
MAN

_Harry Waters Jr._

1992

**Name:** Harry Waters Jr.   **Age:** 39   **Occupation:** Actor   **Race/Ethnicity:** African American   **Where Born:** Tulsa, Oklahoma   **Where Raised:** Denver, Colorado   **Presently Reside:** Los Angeles   **Relationship Status:** Co-Habitating with woman and our child   **Education:** Junior year in College   **Socio-Economic Class:** None of your business

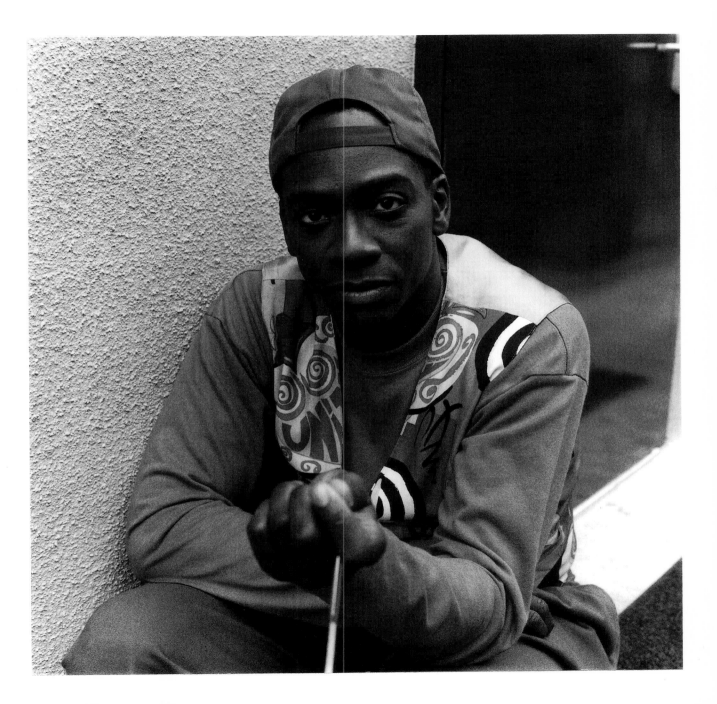

lo mas Importante, de un Hombre es Portarse con Dignidad
y Respeto para vivir bien. si Quieres ser Respetad
debes, Respetar la ley de la Vida es que si
exijis un derecho nesecitas cumplir con
un deber

*TRANSLATION:* The most important thing for a man is to behave with dignity and respect in order to live well. If you want to be respected, you must respect the Law of Life which is if you demand a right, you have to fulfill a duty.

*Name:* Juan S. Hernandez   *Age:* 83 years   *Occupation:* Mechanic for 30 years, retired now   *Race/Ethnicity:* Mexican, but residence in U.S.   *Where Born:* Chihuahua, Mexico   *Where Raised:* Valle de Allende, Mexico   *Presently Reside:* El Paso, Texas   *Relationship Status:* Widowed, one son and one daughter   *Education:* None   *Socio-Economic Class:* Middle class   *Any Other Defining Characteristics or Experiences:* I am missing a leg.   *Philosophical Statement:* The most important thing to me is the money I get from the government.

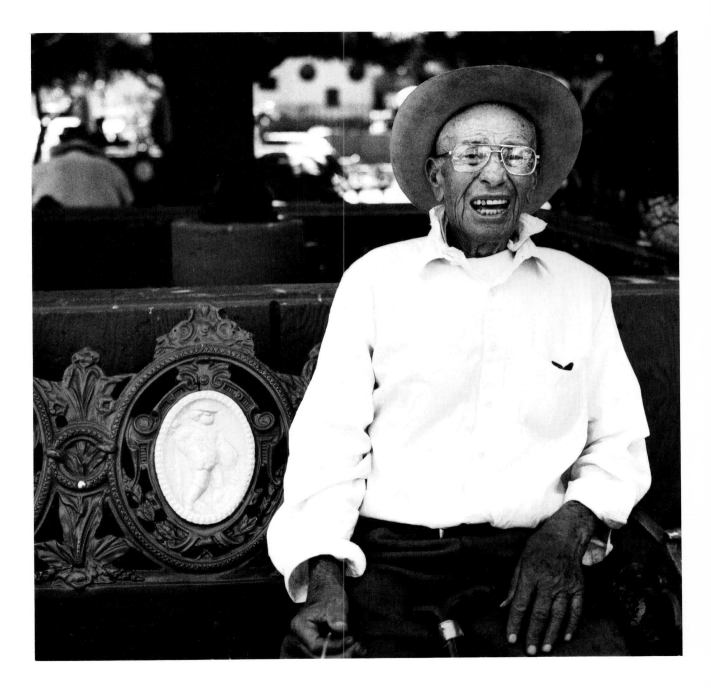

*Being a man means being expected to produce results.*

*Gustavo Zepeda*

**Name:** Gustavo Zepeda   **Age:** 34 years old   **Occupation:** Men's clothing sales and now a restaurant owner   **Race/Ethnicity:** Irish and Mexican   **Where Born:** El Paso, Texas   **Where Raised:** El Paso, Texas   **Presently Reside:** San Francisco   **Relationship Status:** Married   **Education:** Bachelor's Degree   **Socio-Economic Class:** Middle Class upbringing   **Any Other Defining Characteristics or Experiences:** Youngest of five children, the only surviving male child—three brothers, two males died in infancy and one in an accident.

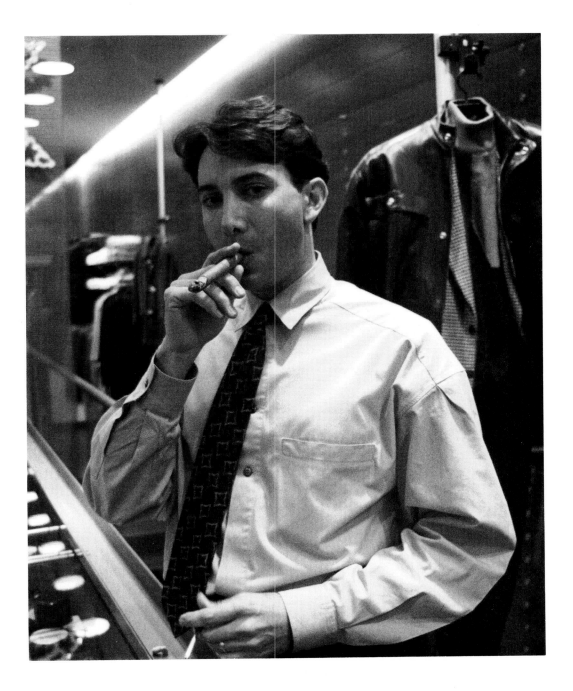

I don't know how to respond to this question. It seems to be an inquiry worthy of thesis yet craving a simplistic one-line comeback. For me, being a man simply means living this particular life in a body which is biologically set up to spread seed. My gender is a mere evolutional technicality. I know there are certain societal differentiations between the terms "man" + "male," but I don't have time for such distinctions. Ultimately, I am a human being. Except for the moments when I piss, get a hard-on or visit "the clinic," I rarely dwell on the fact that I am a man. Yet I know that I am, and I'm quite happy about it — but I'm pretty excited about life in general.

— Greg O'Neill

**Name:** Greg O'Neill  **Age:** 27 y/o  **Occupation:** Bodyworker (hobby); Paralegal (because I have to eat).  **Race/Ethnicity:** Irish & Russian descent  **Where Born:** Springfield, Massachusetts  **Where Raised:** Longmeadow, Massachusetts  **Presently Reside:** San Francisco, California  **Relationship Status:** Polygamous  **Education:** B.A. Communication, U. of So. Maine  **Socio-Economic Class:** Radical-Leftist Queer  **Any Other Defining Characteristics or Experiences:** Actor/Writer/Storyteller  **Philosophical Statement:** Indulge!

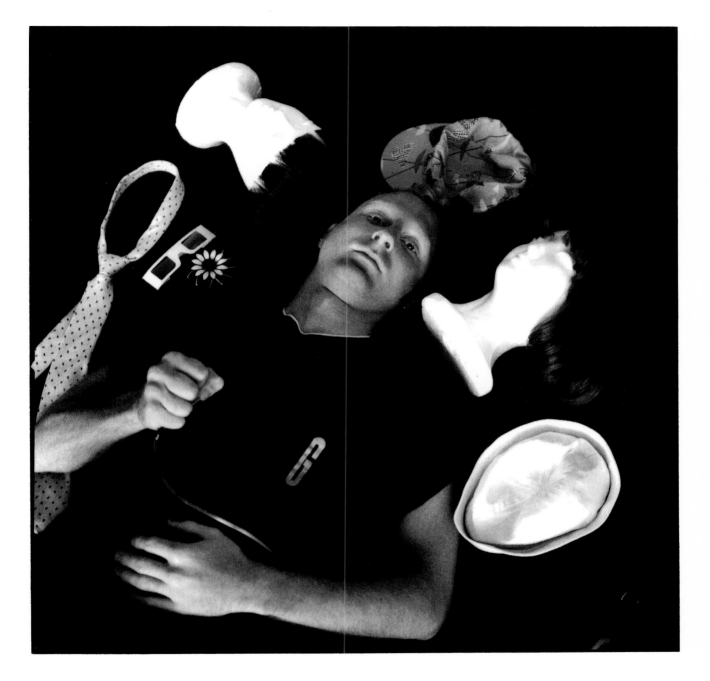

A real man respects other women
A man's voice is deeper, but other
than that there is no difference
between a man and a woman, but
men are supposed to look after
women.

*Name:* Michael Miles  *Age:* 12  *Occupation:* Student  *Race/Ethnicity:* Cherokee Indian  *Where Born:* Asheville, North Carolina  *Where Raised:* Cherokee, North Carolina  *Presently Reside:* Cherokee, North Carolina  *Relationship Status:* Single  *Education:* Elementary  *Socio-Economic Class:* Working class  *Any Other Defining Characteristics or Experiences:* I collect comic books and play baseball.

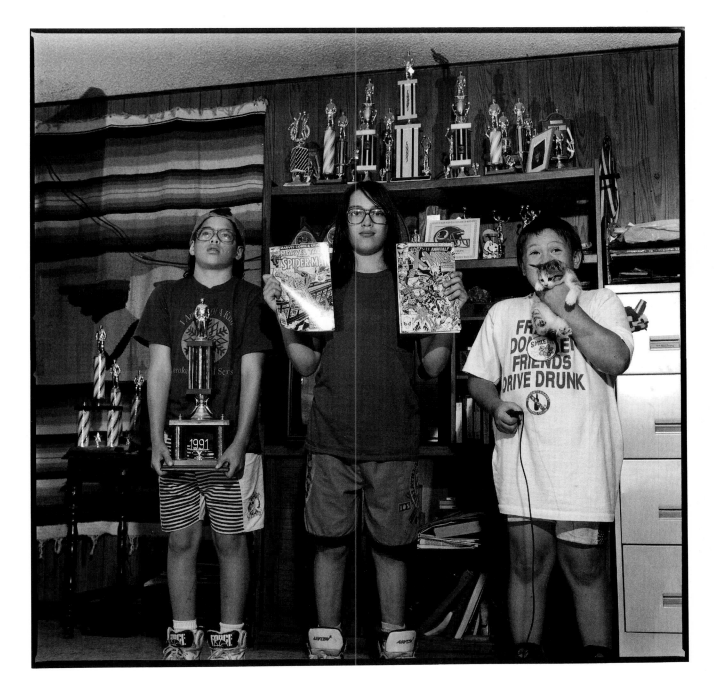

"You need to learn how to work hard to become a Man"

*Name:* Chester T. Kulisa  *Age:* 69  *Occupation:* Dairy Farmer / Soil-Water Conservationist  *Race/Ethnicity:* Pollock
*Where Born:* Dudley, Massachusetts  *Where Raised:* Dudley, Massachusetts  *Presently Reside:* Dudley, Massachusetts,
by choice  *Relationship Status:* Married  *Education:* Agricultural College  *Socio-Economic Class:* Lower Class  *Any Other
Defining Characteristics or Experiences:* We run a dairy farm and a youth hostel. I am regularly picked as a consultant for
coping with agricultural problems including Eastern Europe and developing nations.  *Philosophical Statement:* I like to make
myself useful with the people I meet each day.

94

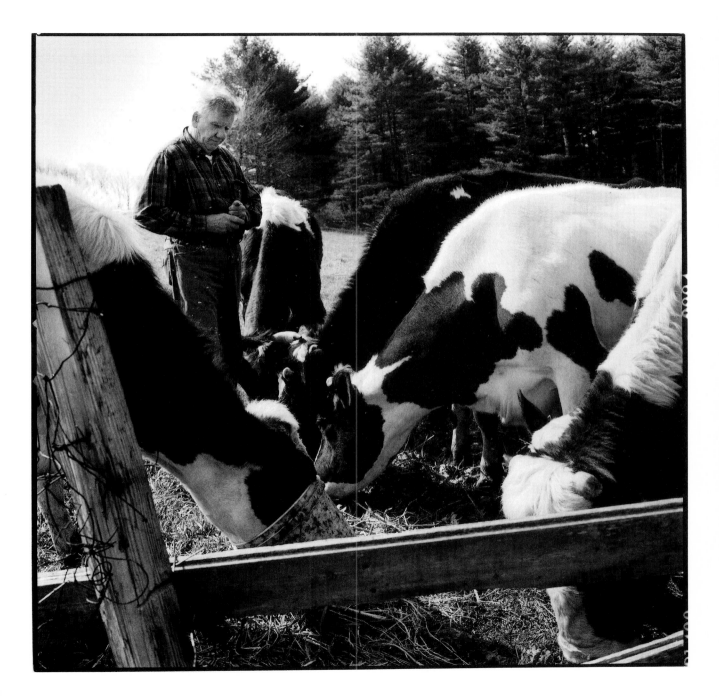

*A man takes care of his woman.*

**Name:** George Jimenez   **Age:** 26   **Occupation:** Sales Representative/clerk   **Race/Ethnicity:** Mexican Origin, father & mother —Mexican   **Where Born:** El Paso, Texas   **Where Raised:** El Paso, Texas   **Presently Reside:** El Paso, Texas   **Relationship Status:** Married   **Education:** High School   **Socio-Economic Class:** Poor   **Any Other Defining Characteristics or Experiences:** I have 18 brothers and sisters.   **Philosophical Statement:** Treat people the way they treat you. And be as friendly as you can towards them.

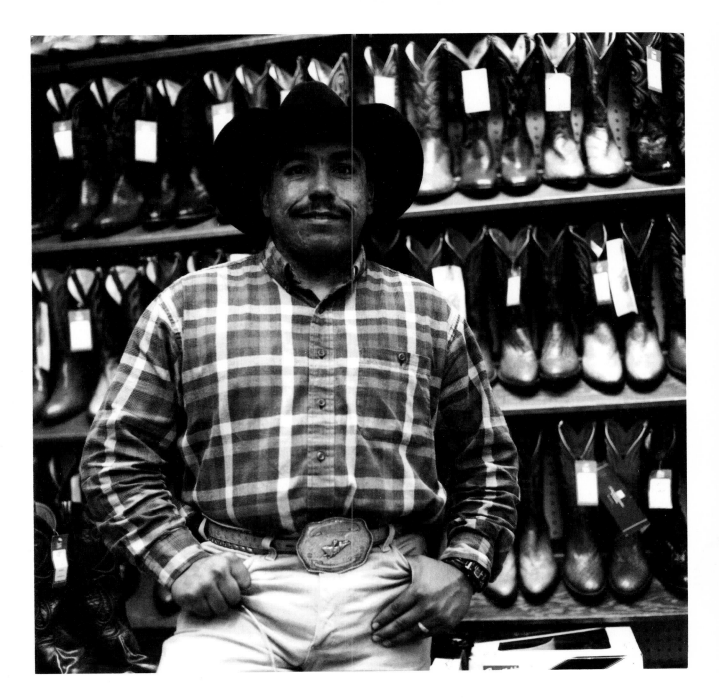

. man and woman have the same rights

In the home a person with the better character and stronger knowlege may lead and manage the home works. need not keep woman working in the home. man works outside according to the old customs that man is more important than the woman. In the society it is also true.

Hung Chi Shen

nov. 19. 1992.

Name: Hung Chi Shen   Age: 80   Occupation: Teacher   Race/Ethnicity: Yellow   Where Born: Beijing, China   Where Raised: Beijing, and various places in China   Presently Reside: Berkeley, California   Relationship Status: Divorced in 1971, after 32 years, remarried in 1989 in Shanghai, but the new wife ran off five months after receiving her green card. Now I am alone, but have 8 children and 11 grand-children.   Education: University graduate, from Beijing Normal University (teachers college)   Socio-Economic Class: Not very poor, father is a judge, have land in the country and many houses in Beijing.   Any Other Defining Characteristics or Experiences: I like tea.

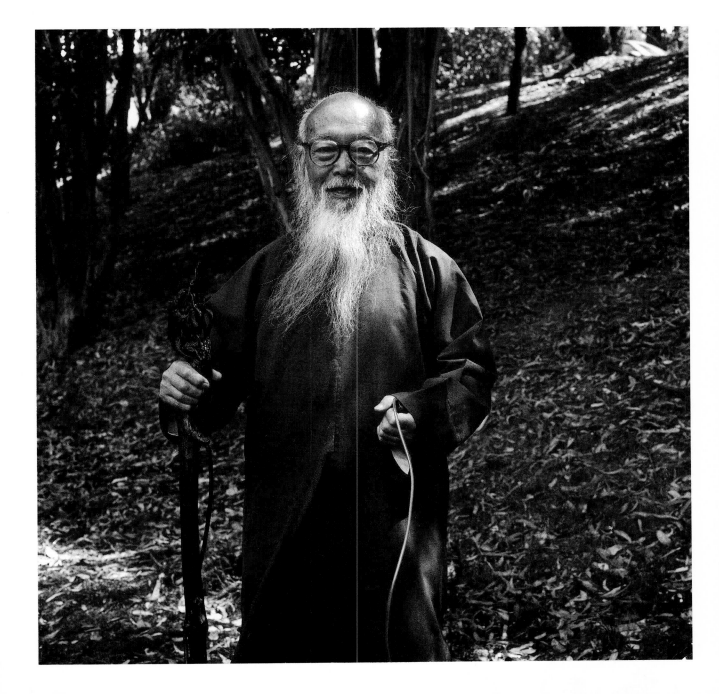

WHILE IN THE MILITARY, I CAME TO SEE FAVORITISM TOWARDS WOMEN QUITE FREQUENTLY. THE IDEA THAT THIS IS A MALE DOMINANT SOCIETY BECAME PAINFULLY OBVIOUS TO ME. I FELT I HAD TO OUT-PERFORM THE WOMEN IN ORDER TO GAIN SOME RESPECT. THE EXPECTATIONS PLACED ON ME BY MY "SUPERIORS," AND THOSE I PLACED ON MYSELF, COMBINED TO FRUSTRATE AND ANGER ME. I GENERALLY FELT QUITE HELPLESS AND INSIGNIFICANT. THEREFORE, BEING A MAN IS A CONSTANT STRUGGLE FOR SELF-RESPECT, RECOGNITION, AND PRAISE.

*Name:* Eric Christianson  *Age:* 24  *Occupation:* Photographer  *Race/Ethnicity:* Regular Caucasian, I'd say.  *Where Born:* Washington, D.C.  *Where Raised:* Washington, D.C.  *Presently Reside:* Alameda, California  *Relationship Status:* Single  *Education:* High School and U.S. Navy school of photography.  *Socio-Economic Class:* Upper middle class upbringing  *Any Other Defining Characteristics or Experiences:* Avid bicyclist. Advanced diver qualified. Five years in military with photography being the main job I performed. Extensive travel.  *Philosophical Statement:* I hate, no, I absolutely loathe indecision and inconsistency (in myself and others). And I'm very cynical, probably as a result of the military. My philosophy of life may be defined as a yearning for as much experience and knowledge as I can get, and be as open as possible without letting my cynicism get in the way.

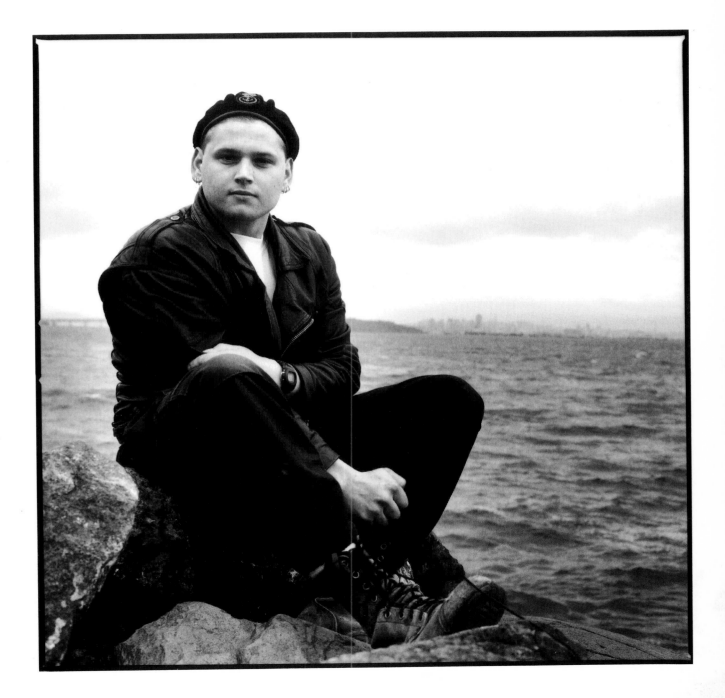

What its like to be a man?

Well it used to be like you was the key of the world, today with all the womens lib going on and women becoming self-dependent, its doesn't mean a great deal to me, sometimes I wonder what it would be like to be a women, don't take me wrong I'am Happy being a man, but sometimes I think it might be easier being a women.

The government is making it easy for the women to accomplish what she wants to and it seems that the man has to work, work, work for everything he has, that is most of the time.

For Instance I'am divorced, the women always seems to make out, she marches haself right up to the local Human Services department and gets about everything she needs to live, Food stamps, Fuel assistance, Medicaid, rent subsidized, AFDC and so on. Take the man whoes divorced, he has to work his ass off to meet child support payments because human services literally laughs at the men. The men can't get all the needs at this building like the women. The men has to keep working.

The government or local legislature ought to look into these divories more closely, and see what the problems were, instead of just handing assistance out to the women, did it ever occur that the men might need some sort of assistance, or that the men wasn't at blame for certain divorces.

Donald Schwab

**Name:** Donald Schwab   **Age:** 36   **Occupation:** Fisherman   **Race/Ethnicity:** White American   **Where Born:** Rockland, Maine
**Where Raised:** Port Clyde, Maine   **Presently Reside:** Port Clyde, Maine   **Relationship Status:** Divorced, three children   **Education:** College three years   **Socio-Economic Class:** Middle Class   **Any Other Defining Characteristics or Experiences:** Basically I've lived at sea a lot, seeing many experiences, which I don't know if that's good or bad. My life is very basically cut and dry.   **Philosophical Statement:** Hard work pays off most of the time.

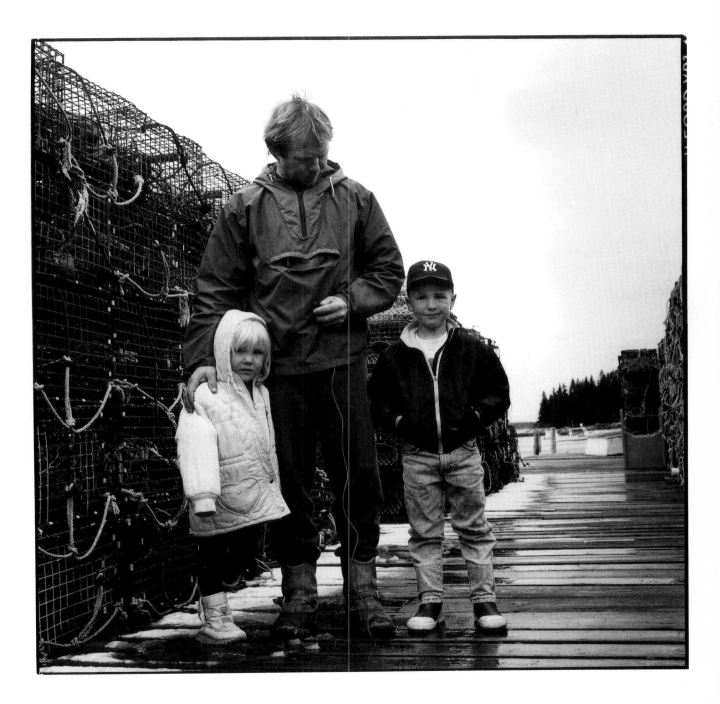

*To be a man is the result to be first a child........*

*Sergio Premoli*

**Name:** Sergio Premoli   **Age:** 50, exactly 50   **Occupation:** Creative artist   **Race/Ethnicity:** Italian   **Where Born:** Rome, Italy
**Where Raised:** Florence, Italy   **Presently Reside:** Venice, California   **Relationship Status:** I am divorced and I have a lover.
**Education:** Psycho-Analyst   **Socio-Economic Class:** I grew up in a very intellectual family.   **Any Other Defining Characteristics or Experiences:** I went through the darkness of the darkness of the subconscious emotion and I enlight myself coming out with the only faith who count which is love.   **Philosophical Statement:** Francis of Assisi, he wrote a long time ago to love the sun and to love the moon. I said to love the trees because they are less and less and we need more and more.

104

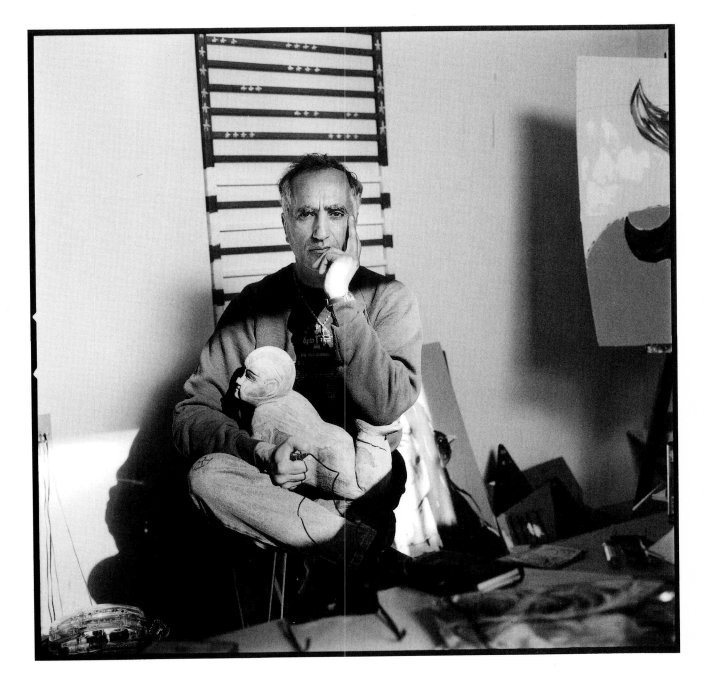

A MAN is about having Responsibility AND to have A job and taking care of his family. When I grow up I want to be tall because I WANT to play Basketball, And also A Man Should bE A person that someONE can cout on.

BEiNG A MAN

**Name:** Adrell Burrell  **Age:** 13  **Occupation:** School  **Race/Ethnicity:** Black  **Where Born:** Oakland, California  **Where Raised:** Oakland, California  **Presently Reside:** Oakland, California  **Relationship Status:** Girlfriend  **Education:** School 8th grade  **Socio-Economic Class:** Middle  **Any Other Defining Characteristics or Experiences:** I have a lot of trophies.  **Philosophical Statement:** Be honest.

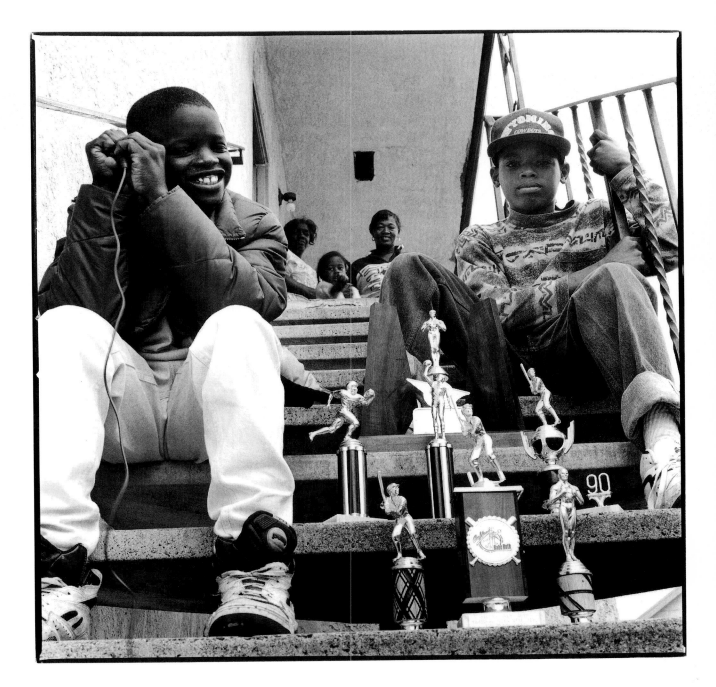

Being A man is acting more mature and responsible. And Also having big mucsle's. A man is raising a family too. And have a job to support them with.

**Name:** Aorrell (Bo) Burrell   **Age:** 14   **Occupation:** School   **Race/Ethnicity:** Black   **Where Born:** Oakland, California   **Where Raised:** Oakland, California   **Presently Reside:** Oakland, California   **Relationship Status:** Girlfriend   **Education:** School 8th grade   **Socio-Economic Class:** Middle (between rich and poor)   **Any Other Defining Characteristics or Experiences:** I play all sports.   **Philosophical Statement:** Have a good attitude.

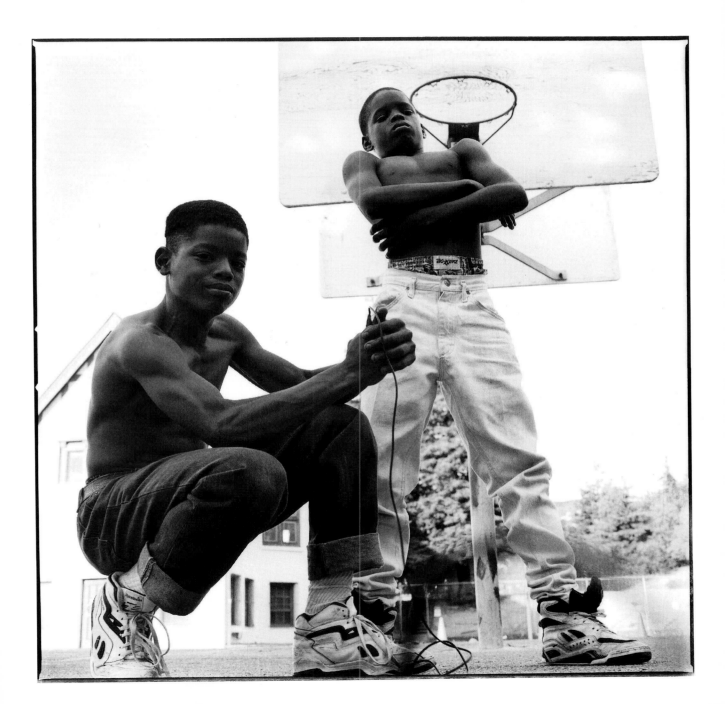

Being a man is for me a confusing and paradoxical muddle. Each of my many identities carries with it a jumbled inheritance of power and powerlessness. Ideally, I want to tap my power, in order to achieve, and accomplish, and improve the world. But so much of my power as a man, and as a white man, exists on the delicately unspoken fringes of oppression; the tendency to exploit others is innate in all men. On the other hand, my experiences as a Jew, a man with a disability, and as a gay man give me a common bond, an empathy, with those on the margins. But I cannot obsess over that marginality, nor can I ignore it. The tasks of my life will be: to use power and strength in the service of others, as a means rather than an end in itself, and to draw on my powerlessness as a means of understanding others, rather than letting it keep me mired in depression and insecurity. Strength and compassion together, not to start a movement, not to sell books, but simply to make life better and more humane for all of us. My friends often tell me that I spend too much time saving other people. I know my self, my needs, my fears well enough to know that most of the energy I expend on others comes back to me eventually. This, although I create rescue and refuge for others, I am simultaneously creating refuge for myself as well, hopefully enough to help me meet the frightening and stimulating challenges of the future.

*Danny Kodmur*

***Name:*** Daniel Kodmur   ***Age:*** 28   ***Occupation:*** Graduate Student, Actor, & occasional activist   ***Race/Ethnicity:*** Ethnicity is Eastern European Jewish, but I don't really recognize the category of ''race.''   ***Where Born:*** Los Angeles, California ***Where Raised:*** Los Angeles, California   ***Presently Reside:*** Berkeley, California   ***Relationship Status:*** Single   ***Education:*** Bachelor's Degree in History with honors from Stanford University in 1987. M.A. in History, University of California, Berkeley, 1989. Ph.D. expected 1994.   ***Socio-Economic Class:*** Other people would say we were upper middle class, but we would say that we were middle class because we have the Depression monkey on our back, and acting like you have a lot of money is still a bad thing.   ***Any Other Defining Characteristics or Experiences:*** I have a physical disability, and I am gay. ***Philosophical Statement:*** Even though it is draining and painful, I try to embody friendship and empathy in my interaction with other people.

110

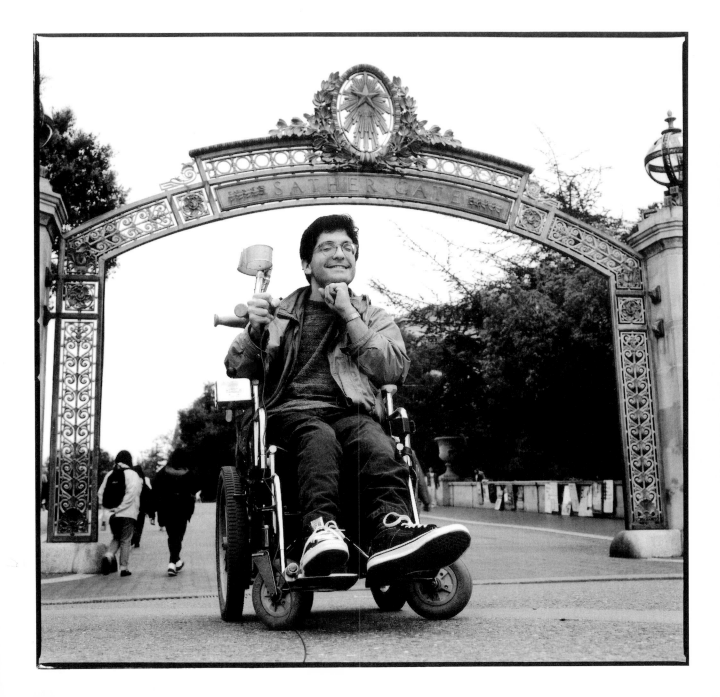

It is Sweat

According to the Bible, Man has been created to be Sweated. Also, in Chinese character Man is "男" which means a field or land has to be taken care of by power — Man has to work hard to live. I have wife and 5 years and 3 years old daughters who give me happiness every moment. That is why I am happy even though I am working 80 HRS a week without weekend. and I strongly beleive that I'll have better & quality life as long as I keep up with heavy Responsibility

*Steven Y*

*Name:* Steven Yi  *Age:* 39  *Occupation:* Dry Cleaning Owner  *Race/Ethnicity:* Asian  *Where Born:* South Korea  *Where Raised:* South Korea  *Presently Reside:* Woodside, Queens, New York  *Relationship Status:* Married with two children  *Education:* College Graduate  *Socio-Economic Class:* Middle Class  *Any Other Defining Characteristics or Experiences:* I would like to play tennis very well, and watch most sports games such as tennis, basketball, football, so forth. I am also a Baptist.  *Philosophical Statement:* I still believe that this is the best place to make dreams come true for people who are willing to challenge for their life. I work from early in the morning to late in the day to get independent financially sooner. I have been working about 80 hours a week consecutively for the last 11 years and attending college classes for 8 years.

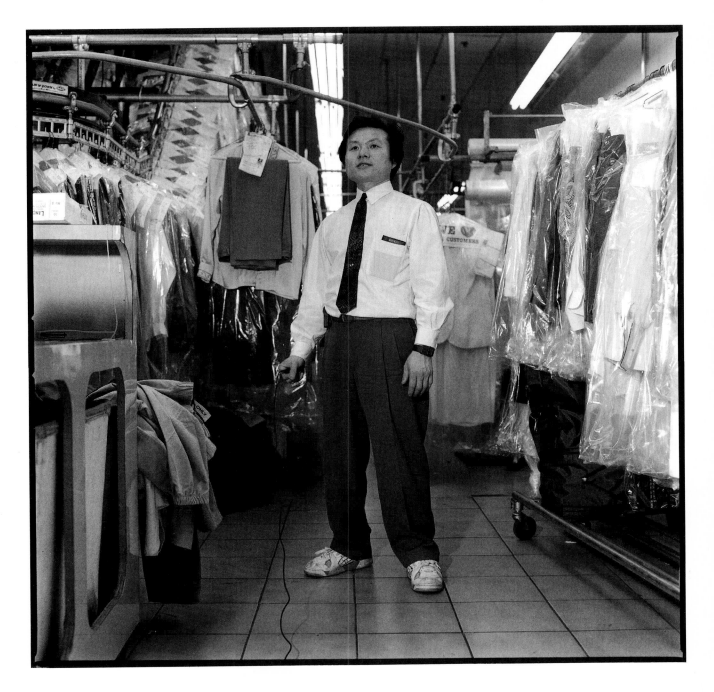

I'VE BEEN ASKED "WHAT DOES IT MEAN TO BE A MAN?" MY FIRST RESPONSE IS, I DON'T KNOW. THEN I WONDER, BY WHAT CRITERIA WOULD I CONFINE A PERSONAL DEFINITION? IMMEDIATELY I THINK OF WOMAN, FROM WHICH ALL HUMANITY, MALE & FEMALE COME & ARE NURTURED FIRST. SO, I SUPPOSE, TO BE A MAN MEANS TO BE VULNERABLE, RESPECTFUL, HUMBLE, RESPOND-ABLE, WITH PEACEFUL DELIBERATION. PROBABLY NOT UNLIKE WHAT I WOULD THINK IT TO BE A WOMAN.

*Name:* Artis  *Age:* 44 years  *Occupation:* Entertainment is my vocation, what I do is to keep on breathing and being me. *Race/Ethnicity:* Don't know my heritage directly, I'm not all that interested except that I feel ashamed of what the Caucasian race has done on this and other continents. But I'm proud to be ashamed.  *Where Born:* Kodiak, Alaska  *Where Raised:* Seattle, Washington  *Presently Reside:* Itinerant since 1974  *Relationship Status:* Father, Grand-father, and single.  *Education:* Huh? (chuckles)  *Socio-Economic Class:* Ugliest word in the English language  *Any Other Defining Characteristics or Experiences:* It seems to me that life is a glorious imposition.

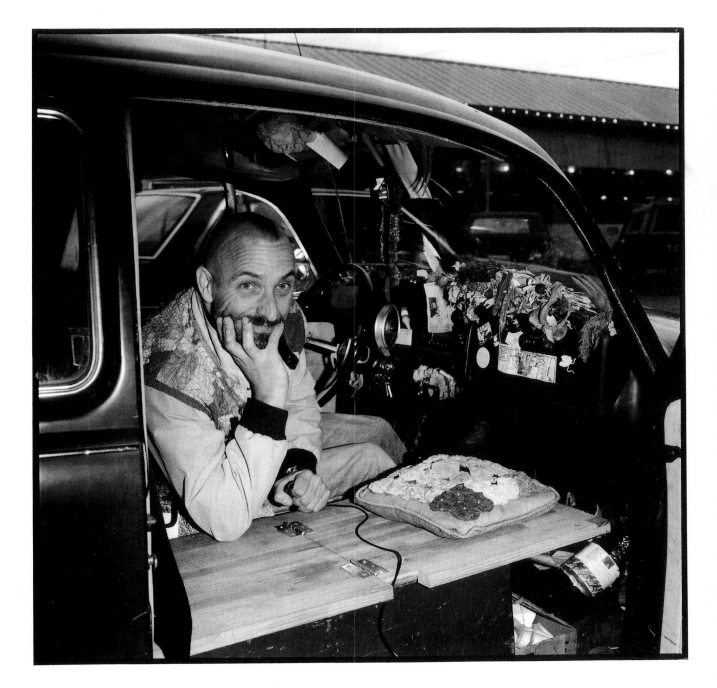

To be a man is a thousand times more complicated than we can understand, and yet, the process is simple. To be a man, one must make a journey that confirms he is a man. The journey must have a testing phase, a searching phase, a conquering phase, and a phase where a new status or recognition is made. The process builds temples and pillars in our minds that confirm us as man.

**Name:** Robert Cole Church  **Age:** 33  **Occupation:** Counselor at Elementary School  **Race/Ethnicity:** Anglo  **Where Born:** Roanoke, Virginia  **Where Raised:** Roanoke, Virginia  **Presently Reside:** Sylva, North Carolina  **Relationship Status:** Married with children  **Education:** M.Ed. Counselor Ed. at U. of South Carolina  **Socio-Economic Class:** Middle  **Any Other Defining Characteristics or Experiences:** Traveled extensively in Europe, Africa, and Asia. I have worked in Europe for two and a half years. I have worked for the Cherokee Indians for four years to date.  **Philosophical Statement:** Be good, have fun. Work, play, and never lose an insight for humor.

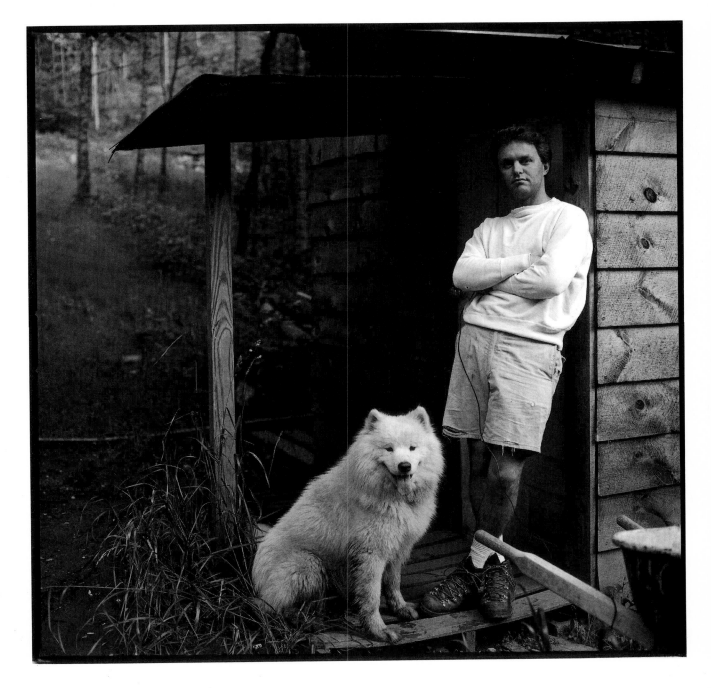

What is it to be a Man?

— To know myself. Both my Latin Side as well as my anglo Side. To try and live up to the expectations I've been raised with, and know when those expectations are not right for me. Coming into my manhood has taught me Odifficult lesson's, Lesson's I still struggle with, But lesson's, I realize I must discover on my own, Not what other's tell me it is to be a man. Being Scared and yet not falling down to that fear is the lesson I most strongly fight. today.

**Name:** Aldo Bermudez   **Age:** 24   **Occupation:** Unemployed Architect   **Race/Ethnicity:** Half Nicaraguan, half Cuban, born in the United States   **Where Born:** San Francisco, California   **Where Raised:** San Francisco, London, Singapore, Washington D.C.   **Presently Reside:** California   **Relationship Status:** Single . . . forever single, actually   **Education:** Architecture, traveling around, and living more than anything . . . seeing the things that I see   **Socio-Economic Class:** Upper Middle Class   **Any Other Defining Characteristics or Experiences:** My mother's death really helped me to find who I was. Even today, the realizations I made after her death are still a driving force. My father is also very much a role figure in my life. I look up to him as a person. I want him to be proud to know the person that I am.   **Philosophical Statement:** Keep things simple. Be responsible for my actions and be prepared to take the consequences for what I do.

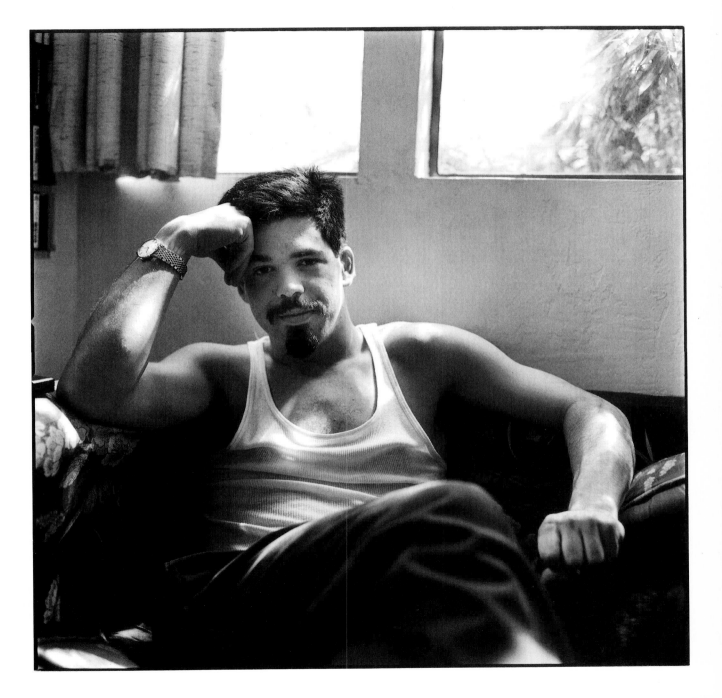

PARA MI EL CONSEPTO de ser hombre, ES. AFRONTAR TODOS LOS deveres. que TIENE uno EN LA VIDA como hijo, como padre como hermano y como ser UTIL-A. LA SOCIEDAD. que Le rodea EN EL TRANSCURSO de SU EXISTENCIA.

OSCAR. RAMIREZ.

*TRANSLATION:* For me, the concept of being a man is to confront all the duties one has in life as a son, as a father, as a brother and as a useful part of the society that surrounds him in the course of his life.

*Name:* Oscar Ramirez  *Age:* 45  *Occupation:* Valet parking  *Race/Ethnicity:* Latino  *Where Born:* Guatemala  *Where Raised:* Guatemala  *Presently Reside:* Los Angeles, California  *Relationship Status:* Single  *Education:* Enfermero (nurse)  *Socio-Economic Class:* Clase media (middle class)  *Any Other Defining Characteristics or Experiences:* Put yourself in God's hands every day. Act for the good of society or your fellow man  *Philosophical Statement:* I find contentment by serving my parents, family and friends.

120

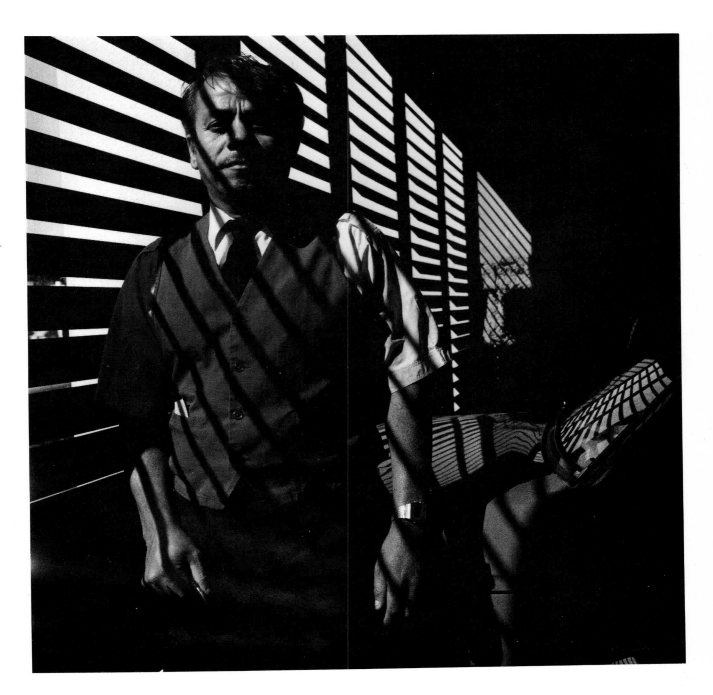

My first impressions of what it meant to be a man were that I could drink beer and fart in front of other people (as my father did) Only later did I come to realize that, as opposed to some women, to be a man meant that I was my own ultimate judge and jury, responsible for my own beliefs and actions and their consequences. Funny how such responsibility could ultimately be so freeing.

**Name:** Dr. Keith A. Gockel   **Age:** 35   **Occupation:** Physician (disabled)   **Race/Ethnicity:** Caucasian   **Where Born:** Staunton, Illinois   **Where Raised:** Staunton, Illinois   **Presently Reside:** San Francisco, California   **Relationship Status:** Monogamous, Gay   **Education:** B.S. Civil Engineering, M.D.   **Socio-Economic Class:** Lower Middle Class   **Any Other Defining Characteristics or Experiences:** Fighting AIDS since 1987   **Philosophical Statement:** All that matters in the end is the love you give and receive. So simply profound.

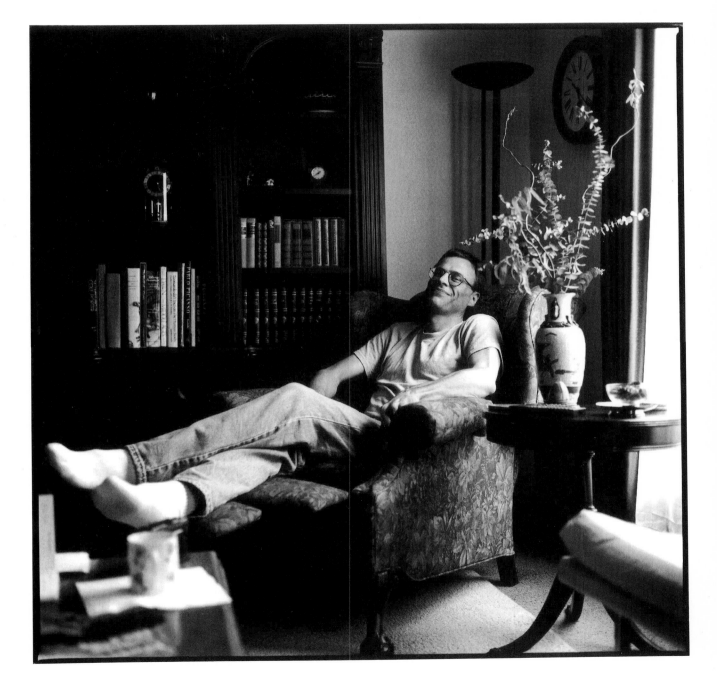

*I cannot define what it is to be a man without discussing what it is to be an African-American man. My journey towards fulfillment on this planet, in this racist country, has been more difficult because of my race. The strength of my forefathers, and my knowledge of their struggle, have brought me to full fruition as a man. Full fruition is honor and integrity.*

**Name:** John E. Sweeney   **Age:** 41 years old   **Occupation:** Attorney   **Race/Ethnicity:** African-American   **Where Born:** District of Columbia   **Where Raised:** Los Angeles, California   **Presently Reside:** Los Angeles, California   **Education:** B.A., USC; J.D., Southwestern   **Socio-Economic Class:** Upper-middle class   **Any Other Defining Characteristics or Experiences:** Sportsman. Sports, that's my thing.   **Philosophical Statement:** I'm a participant in life and not a spectator. In other words, I get involved.

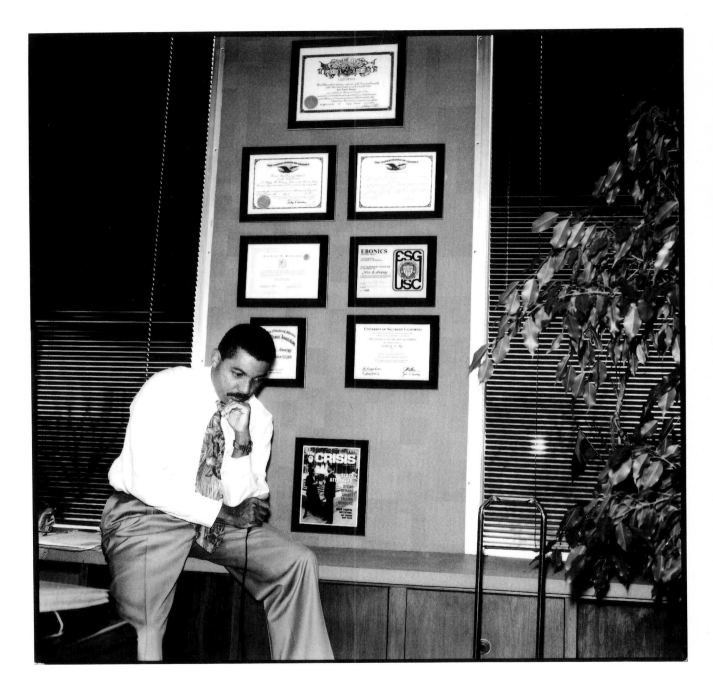

To be a man is to have some identified Principles and goals. These Principles are mostly thought of as unchangables. But a man may reinterpret and reidentify them from time to time. For example I think of myself as extremely honest but in the meanwhile I don't deny that I have made some lies. I can say that I lied when I thought that honesty would never work in a Particular situation. Others may beleive that they would never cheat on their Partners. They do sometimes. They may say that they were forced to do so. My honesty was Conditioned by being understood and the later principle was Conditioned by being respected

*Name:* Mohamed B. Hassan  *Age:* 31  *Occupation:* A student and a cab driver  *Race/Ethnicity:* Arab  *Where Born:* Alexandria City, Egypt  *Where Raised:* In Egypt  *Presently Reside:* New York, USA  *Relationship Status:* Single  *Education:* M.B.A. in marketing—Long Island University  *Socio-Economic Class:* Poor by American standards  *Any Other Defining Characteristics or Experiences:* I am a Moslem, but not very devout.  *Philosophical Statement:* Basically I am religious even though I don't look like I am. I try to interpret everything from a religious point of view.

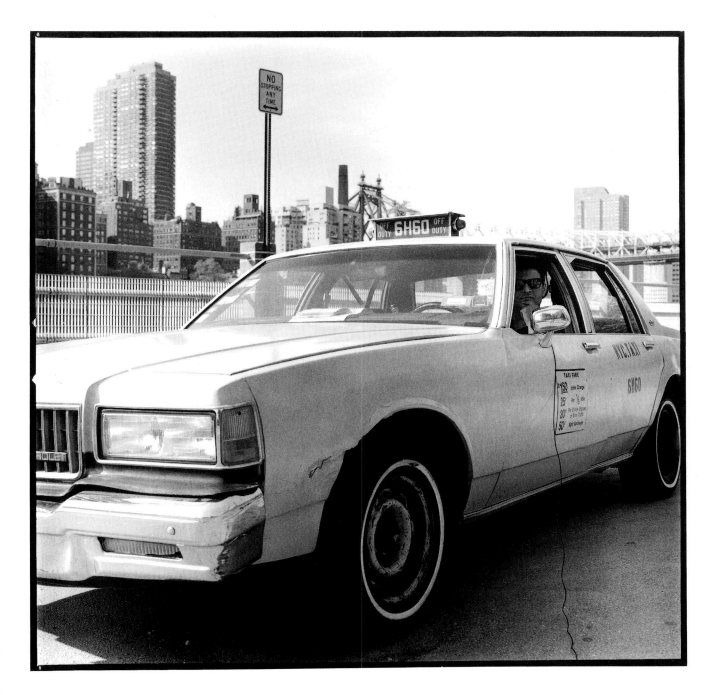

*It's alot harder than Being a Boy.*

*Name:* Mike Zaroudny  *Age:* 21 years  *Occupation:* Clothing Store Owner  *Race/Ethnicity:* Caucasian  *Where Born:* Southern France  *Where Raised:* Arizona and Washington  *Presently Reside:* Seattle, Washington  *Relationship Status:* Recently single  *Education:* High School  *Socio-Economic Class:* Upper Middle  *Any Other Defining Characteristics or Experiences:* World Traveler, I like to go everywhere.  *Philosophical Statement:* Don't get involved with women too seriously, and to see as much as you can possibly see, and try to learn as much as you can, 'cause you only live once.

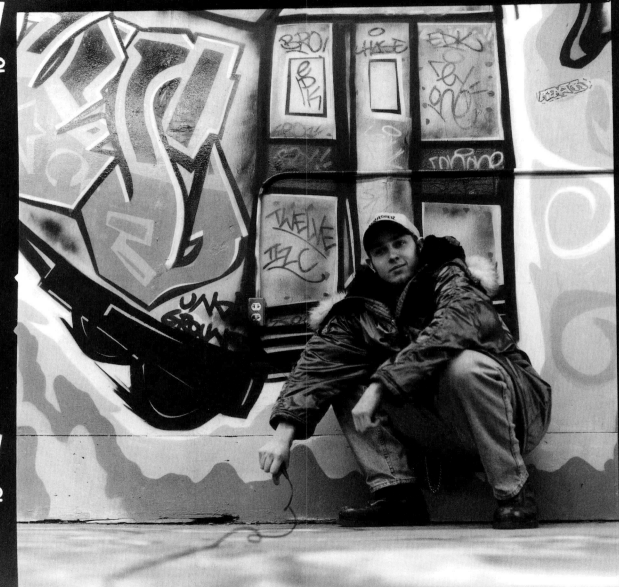

To be a man is like walking a very fine tightrope on issues we truly believe in without having any lateral descension. Men and women should be able to speak freely without concern for whether it is correct or not.

**Name:** Chris Miske   **Age:** 30   **Occupation:** Legislative Assistant / US Senate   **Race/Ethnicity:** White   **Where Born:** Passaic, New Jersey   **Where Raised:** All over with a military family, but I consider Seattle, Washington, my home.   **Presently Reside:** Washington, D.C.   **Relationship Status:** Single   **Education:** B.A. and M.P.A. U. of Washington   **Socio-Economic Class:** Middle Class   **Any Other Defining Characteristics or Experiences:** I lived and traveled all over the world and the country. I've learned that we must all respect others' cultures and values, no matter how much they may offend us.   **Philosophical Statement:** The Golden Rule: Treat others as you would like to be treated.

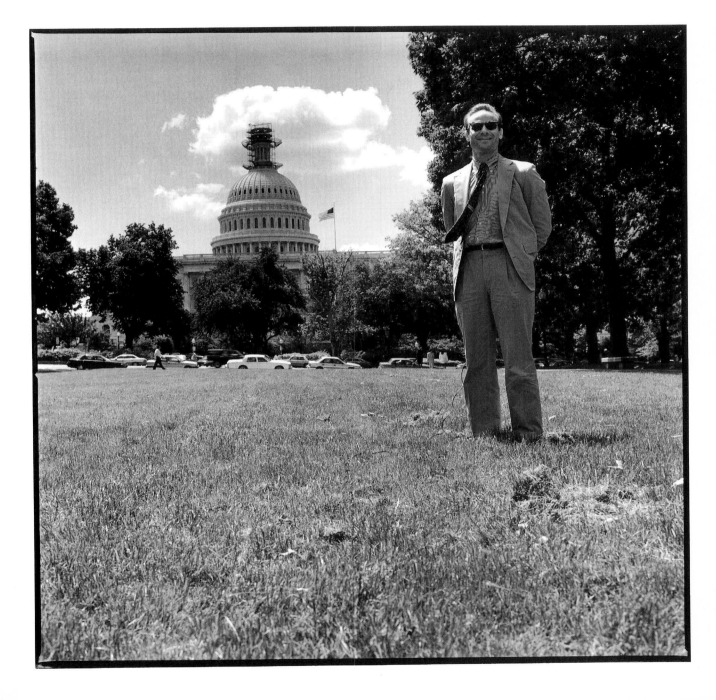

What is it to be A MAN?

Generically, it is essentially to be plagued by that question.

Sexually, it is to ride upon the wild dragon of testosterone.

As a white, European descendant, it is, in 1993, to be hounded for Apologies.

As myself, it is to live w: that regret.

J. White
3/24/93
10:05 A.M.

*Name:* Joseph Paul White  *Age:* 41 years  *Occupation:* Professor-Writer  *Race/Ethnicity:* Caucasian, English-French *Where Born:* Indianapolis, Indiana  *Where Raised:* Indianapolis, Indiana  *Presently Reside:* Lompoc, California  *Relationship Status:* Married, two children and a dog  *Education:* M.A.  *Socio-Economic Class:* Middle-middle to lower-upper-middle class.  *Any Other Defining Characteristics or Experiences:* Married to Dulcie Sinn for 20 years.  *Philosophical Statement:* Ignorance is the root of misfortune.

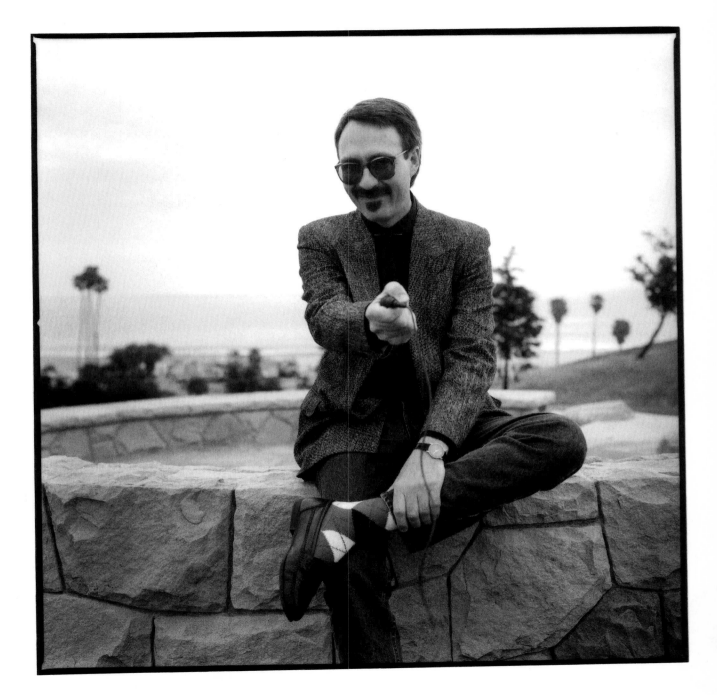

*To be a man you need big muscles a full head of hair or most of it you should be pretty good at sports and be loving caring and have a good education.*

**Name:** Nick Sinn-White   **Age:** 11½ years old   **Occupation:** school student   **Race/Ethnicity:** Caucasian   **Where Born:** Santa Barbara, California   **Where Raised:** Lompoc, California   **Presently Reside:** Lompoc, California   **Relationship Status:** Never married, no girl-friend but I had one. I have friends who are girls but not the kind you go out with.   **Education:** Kindergarten to fifth grade.   **Socio-Economic Class:** Potentially upper-class   **Any Other Defining Characteristics or Experiences:** My favorite basketball player is Shaquille O'Neal, and my favorite baseball player is Don Mattingly.   **Philosophical Statement:** Live for the moment. Don't commit suicide. Stay off drugs.

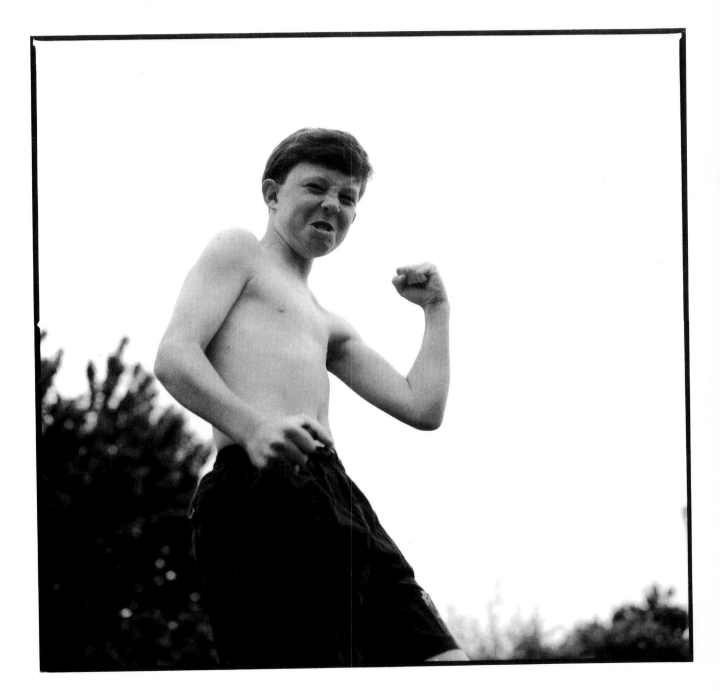

Men can't get in touch with there Feminity

**Name:** Malcolm Hartwell   **Age:** 31   **Occupation:** Not working   **Race/Ethnicity:** Black   **Where Born:** Boston, Massachusetts
**Where Raised:** North Shore, Massachusetts   **Presently Reside:** Gloucester, Massachusetts   **Relationship Status:** Girl-Friend
**Education:** Ninth grade   **Socio-Economic Class:** Poor   **Any Other Defining Characteristics or Experiences:** US Army, 1979–
1982   **Philosophical Statement:** I take it one day at a time.

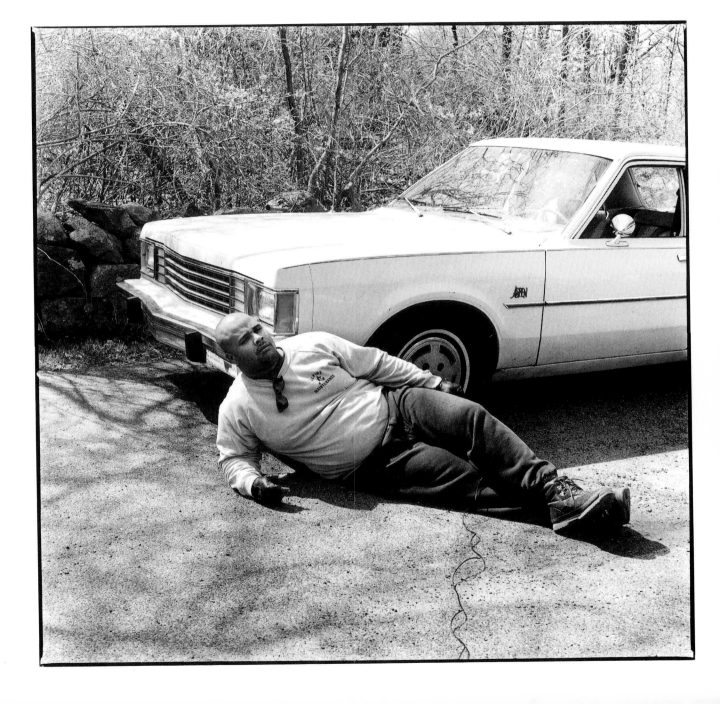

IT's GREAT TO BE A MAN!
The WOMEN HAVE WAY TO MANY
problems, HAVING BABY, PMS.
sentimental VALUes That Resualt
into CRYING OR Despression
But, I Love them ALL EVERY one
Them, I'm JUST GLAD That (me) PERSONALLY
Dont HAVE To Put up with That SHIT

Caluza The HillBilly

**Name:** Robert K. Caluza (HillBilly Bob)   **Age:** 38 years   **Occupation:** Bar business   **Race/Ethnicity:** Grandfather: Naples, Italy; Mother Tennessee   **Where Born:** Indianapolis, Indiana   **Where Raised:** Indianapolis, Indiana; and Chicago, Illinois   **Presently Reside:** New Orleans, Louisiana   **Relationship Status:** Single, have two sons (a little girl died).   **Socio-Economic Class:** Grew up poor, but father has money.   **Any Other Defining Characteristics or Experiences:** Not a religious man, but had a religious experience with a car.

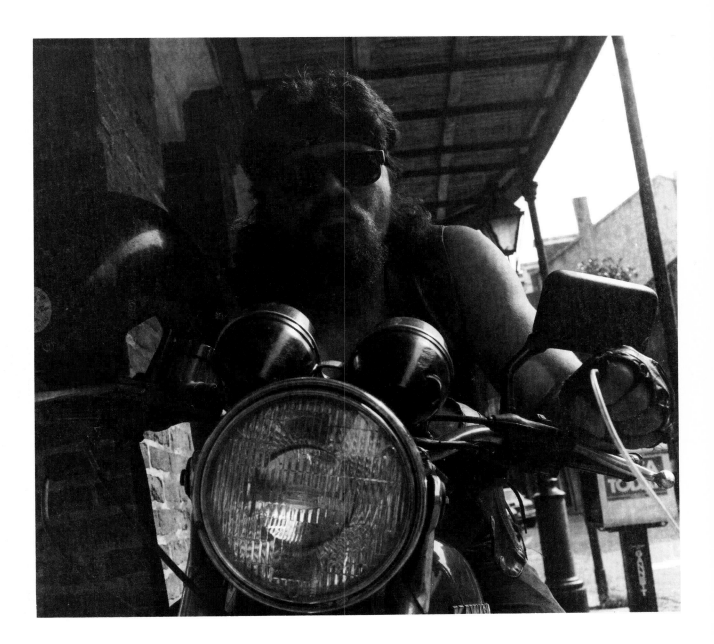

BEING A MAN MEANS HAVING A
DICK AND NOT BEING ABLE TO
GIVE BIRTH — OTHER THAN THESE
TWO THINGS "BEING A MAN"
HAS VERY LITTLE MEANING.
I'M JUST SOME WATER + AIR FLOATING
THROUGH THE COZMOS!

**Name:** Asoka Thomas   **Age:** 49   **Occupation:** Nonprofit program coordinator/Yoga instructor   **Race/Ethnicity:** Mr. X from Planet Strange   **Where Born:** Memphis, Tennessee (in this incarnation)   **Where Raised:** I'm still being raised; the process is incomplete, but much of the early raising happened in Cleveland, Ohio.   **Presently Reside:** Bolinas, California   **Relationship Status:** Nonattached   **Education:** B.A. in fine arts and education, M.A. in early childhood development; still working on doctorate at the University of Life.   **Socio-Economic Class:** Somewhere in between   **Any Other Defining Characteristics or Experiences:** My life has been more rewarding and a greater adventure than I ever had imagined it could be.   **Philosophical Statement:** Things are not as they appear to be . . . nor are they otherwise.

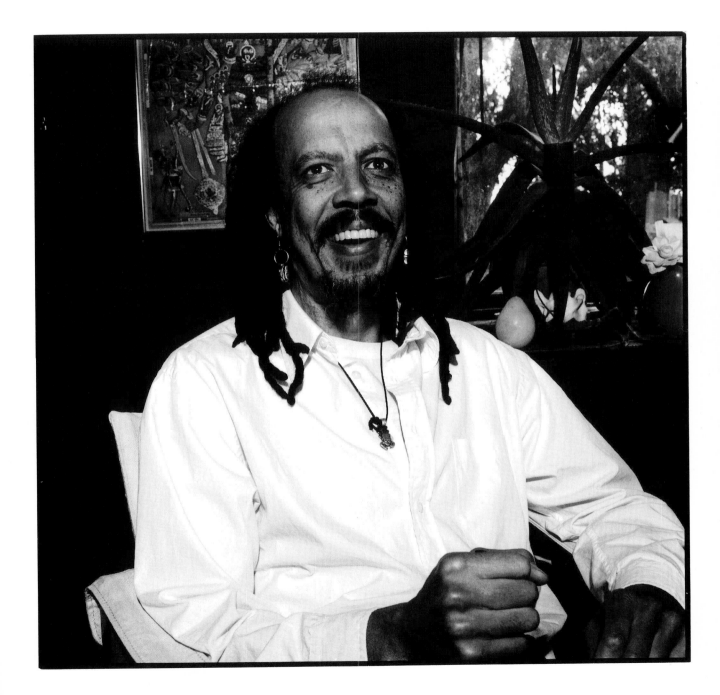

*To decide whether or not to starch your shirts and then to live with that decision.* J.B. Scott
F.J.F.

**Name:** James B. Scott (J.B.)  **Age:** 29 years old  **Occupation:** Musician  **Race/Ethnicity:** White, part Scottish, part German, definitely a musician  **Where Born:** Philadelphia, Pennsylvania  **Where Raised:** Philadelphia, Pennsylvania  **Presently Reside:** New Orleans, Louisiana  **Relationship Status:** Single, no children, but lots of stereo equipment  **Education:** Trained in music in Orlando, Florida  **Any Other Defining Characteristics or Experiences:** A procrastinator, but things always move forward. Live in New Orleans, play Dixieland with the Dukes of Dixieland.

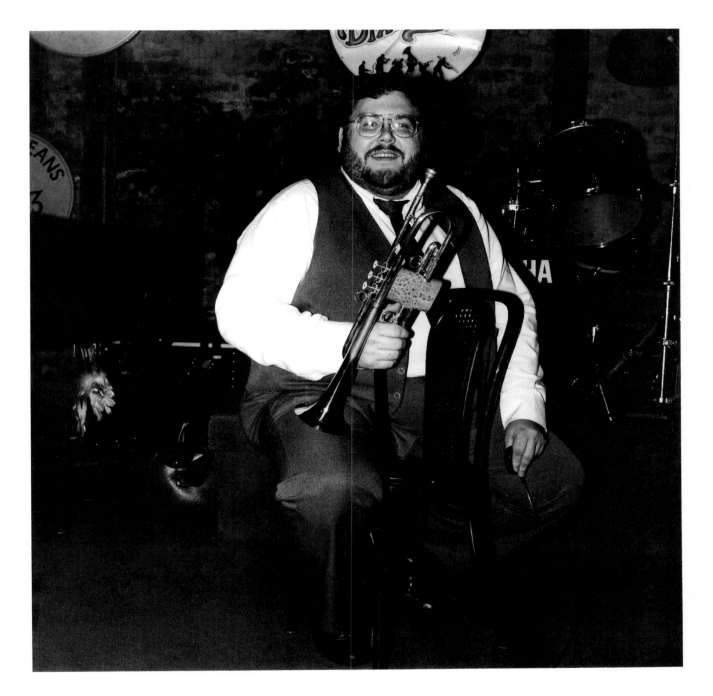

BEING A MAN IS BEING A SURVIVOR AND RESPONSIBLE FOR MY WIFE AND CHILD.

**Name:** Tommy Stevenson  **Age:** 37  **Occupation:** Unemployed  **Race/Ethnicity:** Black  **Where Born:** New York City  **Where Raised:** Washington, D.C.  **Presently Reside:** Homeless in Washington, D.C.  **Relationship Status:** Married, twice  **Education:** Two years of college  **Socio-Economic Class:** Middle-Class  **Any Other Defining Characteristics or Experiences:** I spent twelve years in the USAF, and raised two children in Oakland, California. My mother and father died seven months apart in 1973. I have survived most tragedies throughout my life.  **Philosophical Statement:** Take care of my wife and child. Be kind to others. Treat humans as humans. And above all *NEVER GIVE UP!*

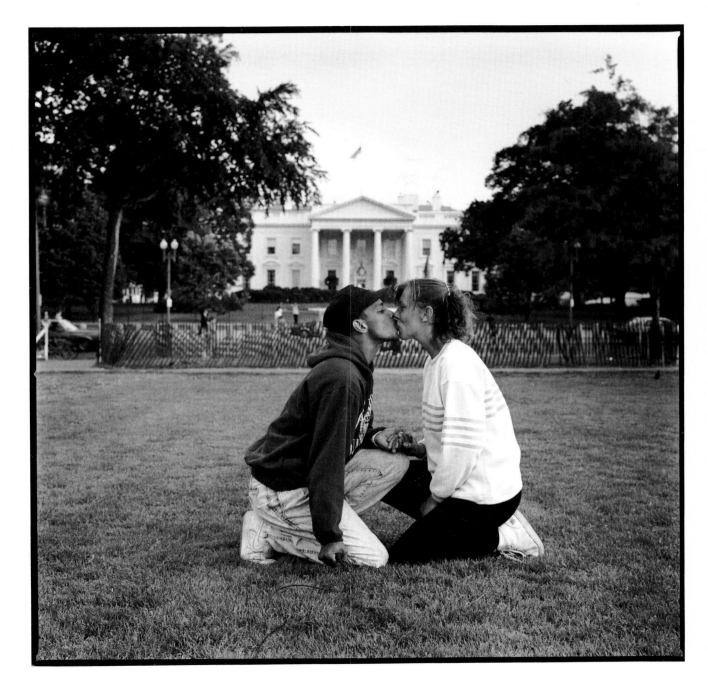

*A Man is Happy in his environment......*

*Name:* Darrell E. McLaurin  *Age:* 28  *Occupation:* Dancer-Singer  *Race/Ethnicity:* African American  *Where Born:* Los Angeles, California  *Where Raised:* Los Angeles, California  *Presently Reside:* West Hollywood, California  *Relationship Status:* Single  *Education:* Attending Santa Monica College  *Socio-Economic Class:* Middle class  *Any Other Defining Characteristics or Experiences:* Proud African American gay male dancing-singing student.  *Philosophical Statement:* Once you make a statement it is useless to you.

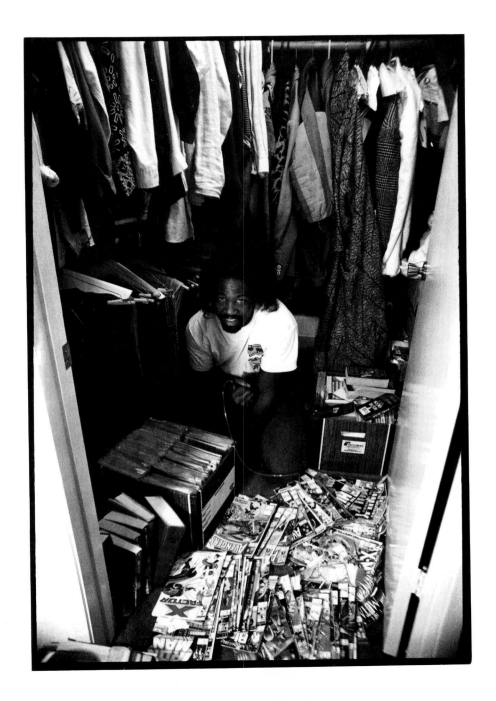

*A man is to be known by the honor he keeps.*

***Name:*** Mark Hansen   ***Age:*** 43, B.D. 9-22-48   ***Occupation:*** Vagabond & wastrel   ***Where Born:*** Suffolk, England   ***Where Raised:*** Suffolk, England   ***Presently Reside:*** El Paso, Texas, but traveling   ***Relationship Status:*** Single, never married   ***Education:*** B.A. English Literature; M.A. French Poetry; M.A. American Authors

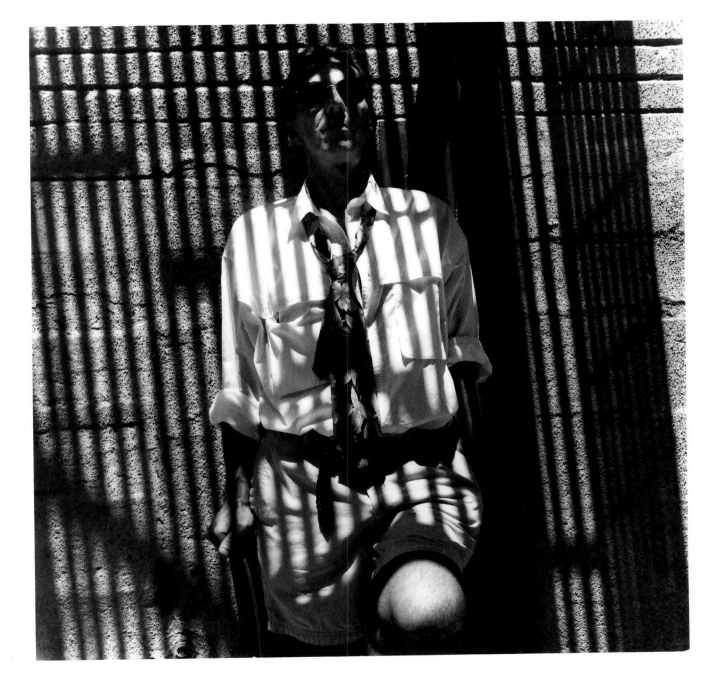

An honest person is a noble work of God.
A good man must have high moral
character and integrity.
A disciplined life should be a life of service.
A man's word will not return to him
empty—

John Gove Prude
"Big Spurs"     John E. Prude

The outside of a horse is good for the
inside of a child.

**Name:** John Gove Prude, "Big Spurs"    **Age:** Born February 27, 1904, right here at Prude Ranch, and grew up at Prude Ranch, and went to school in the same room I was born in with my brothers.    **Occupation:** 47 years a professor, and a cow man all my life, Teaching is my profession, Cowboying is my whole life, Also run a guest Ranch and summer camp.    **Race/Ethnicity:** Mother—Pruitt, from Romance, Arkansas, in 1880, came to sell milk and butter. Father—from Tuscaloosa, Alabama, in 1884; he homesteaded MacDonald Observatory    **Presently Reside:** Prude Ranch    **Relationship Status:** Married, have son and daughter, many grand kids and great grand kids.

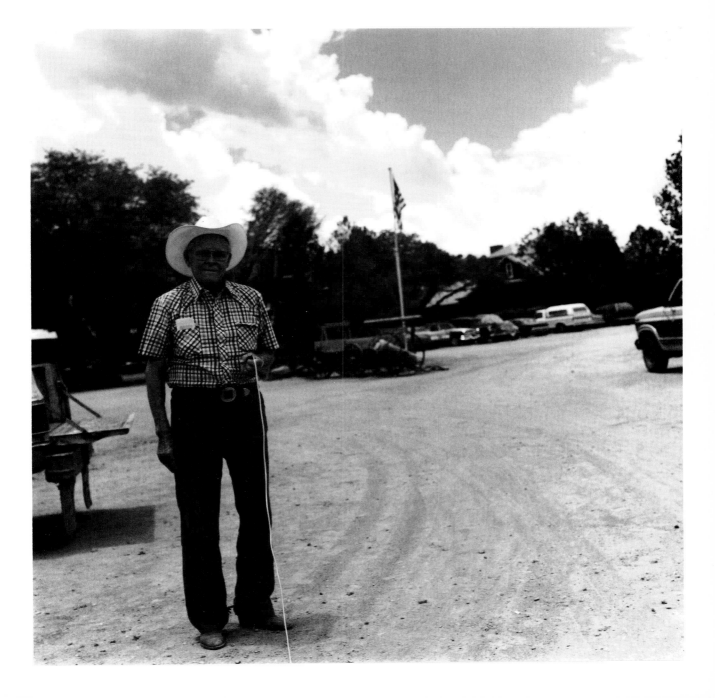

Я НЕ ЗНАЮ ЧТО ЭТО БЫЛО Я МНОГО РАЗ РАСТЕГИВАЛ
ШИРИНКУ ПО МЕРЕ ПРИБЛИЖЕНИЯ ЛЮБОВНИЦЫ
ЭТО БЫЛО КРАСИВО И ЭМОЦИОНАЛЬНО НО НИЗМЕНОЕ
ВЛЕЧЕНИЕ ДЕЛАЕТ МЕНЯ НЕСЧАСТНЫМ. ЛУННЫЙ
ПЕЙЗАЖ ПО ПРЕЖНЕМУ НА ЛУНЕ

Konstantin Titov

*TRANSLATION:* I don't know what it was. I unzipped my fly a lot of times while my lover [female] came near to me— It was beautiful and emotional but basic instinct makes me unhappy. The moon landscape is still on the moon.

*Name:* Konstantin Titov  *Age:* 34 years old  *Occupation:* Artist  *Race/Ethnicity:* Healthy  *Where Born:* Tashkent, Soviet Union  *Where Raised:* Tashkent, Soviet Union  *Presently Reside:* United States, California  *Relationship Status:* Single  *Education:* Art  *Socio-Economic Class:* Very unstable. I have been extremely rich and also extremely poor.  *Any Other Defining Characteristics or Experiences:* No ambitions and no goals, just a participator of something, I don't know what.  *Philosophical Statement:* Any philosophical statement is eventually useless.

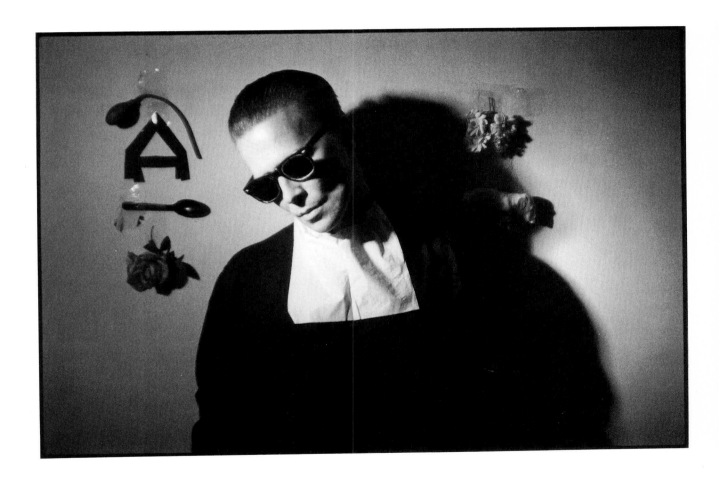

BEING A MAN IS LISTING TO PEOPLE, NOT THINKING
I AM BETTER THAN ANYONE ELSE. AND TO HELP FELLOW MAN
WHEN HE NEEDS ASSISTANCE
I CAN ADD THAT TAKING TIME OFF FAMILY IS A VERY
IMPORTANT PART OF ENJOYING THE FRUITS OF YOU LABOR
AND ENJOYING THE RESULTS.

---

**Name:** Mac Gordon   **Age:** 92 years old   **Occupation:** Paint Business and Hotel/Motel owner and operator   **Race/Ethnicity:** White and Hebrew   **Where Born:** New York City, Hell's Kitchen   **Where Raised:** New York City   **Presently Reside:** Los Angeles, California   **Relationship Status:** Married for 62 & ½ years   **Education:** NYU, business administration. Also U.S. Army Officers Training Corp. SATC—(Students . . . )   **Socio-Economic Class:** Hard-working middle class   **Any Other Defining Characteristics or Experiences:** Been active in all kinds of organizations; elected to City position for three terms. **Philosophical Statement:** Work for yourself, don't spend money needlessly.

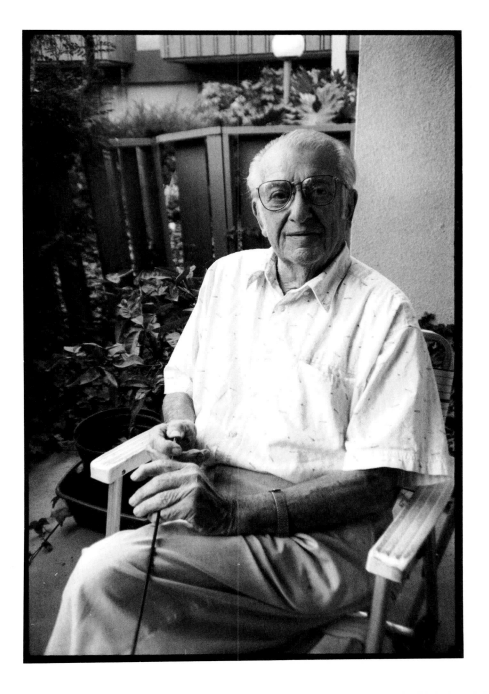

Being a man is being a provider, earning a living, paying bills without question, on Saturday, when you could have been playing golf and having the right to cut up credit cards when it gets out of hand.

*Name:* Phillip Vein  *Age:* 58  *Occupation:* Consultant / Development & Construction Management  *Race/Ethnicity:* White  *Where Born:* Detroit, Michigan  *Where Raised:* LA, California—San Fernando Valley  *Presently Reside:* Encino, California  *Relationship Status:* Married  *Education:* 15 yrs.  *Socio-Economic Class:* Upper  *Any Other Defining Characteristics or Experiences:* Extrovert  *Philosophical Statement:* A country divided is a condominium.

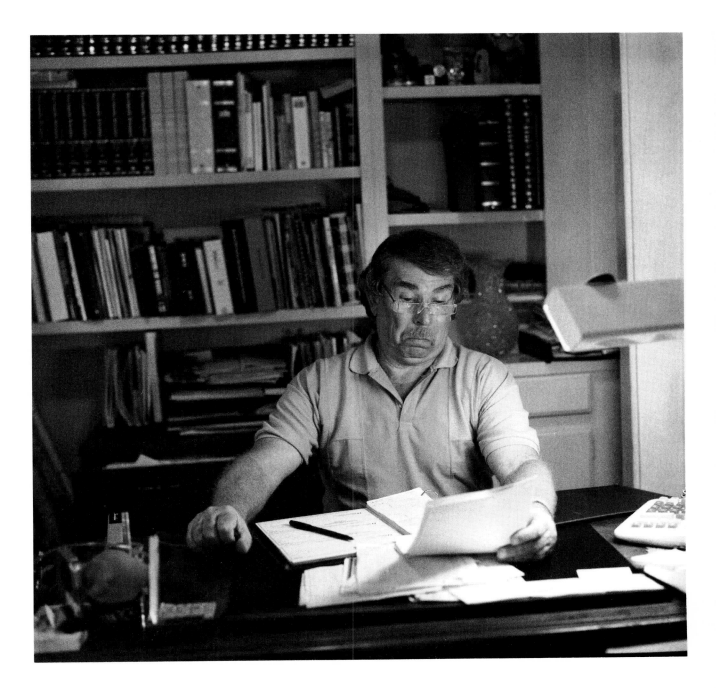

Masculinity is showered on the young boy at a very early age. I learned to take care of myself in a real basic way. Eat all your vegetables, get a good nights sleep, be big and strong. I thrived on those early rules that have become the foundation of a rewarding adult life. I have chosen a career that encourages strength and bravery. My hobbies reflect those early masculine rules with acquired skills — skiing and sailing. My social life has evolved in a similar manner — shoot for the stars or be left behind. Yet, to be a man?

For me, the life course that has taken me through 35 years, has been an extended adolescence. The Fire Department has allowed it to continue extending on. Yet, to be a man, as I see it, one has to become a caring, nurturing father. Many of the firefighters around me are men. Family men. They have to work second jobs, go straight home. I don't. They are fathers. I am not.

Being a man, I have learned how to take criticism. I've even learned how to use it constructively. And I strive to learn from my mistakes since they truly are things I can really call my own. Yes, I love being a man!

*Name:* Edmond O'Mahoney  *Age:* 35  *Occupation:* New York City Firefighter  *Race/Ethnicity:* American Irish  *Where Born:* Bronx, New York  *Where Raised:* New York State  *Presently Reside:* New York City  *Relationship Status:* Single  *Education:* College, SUNY Cortland  *Socio-Economic Class:* Blue Collar Sybarite  *Any Other Defining Characteristics or Experiences:* Approach life like a professional athlete. I'm paid to perform, so I do.  *Philosophical Statement:* Strongly influenced by Rock n Roll music. One album in particular: Billy Joel's *Turnstiles*. One line from one song really stands out: "They say that these are not the best of times, but they're the only times I'll ever know." (Summer, Highland Falls).

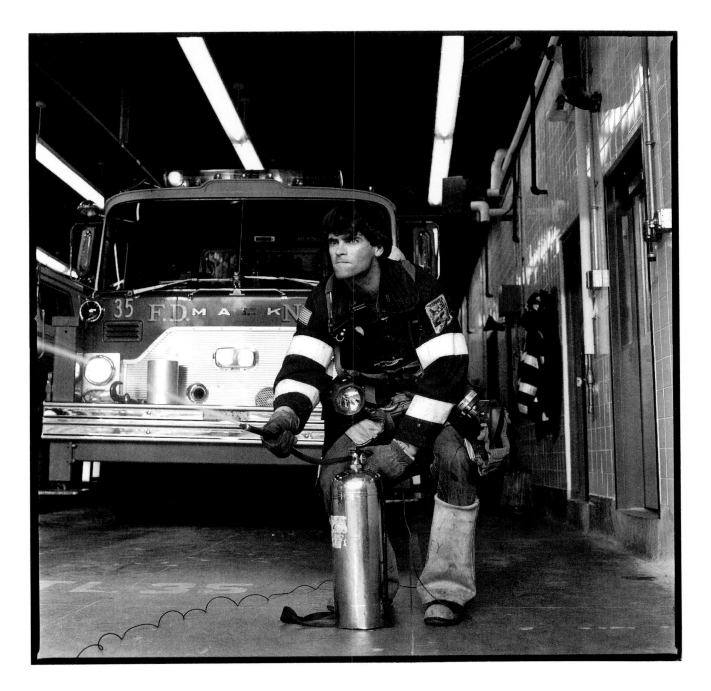

In primitive Times, using physical activity as a means, the male species developed two powerful basic instincts: the need to provide himself and his family with food and shelter and the need to protect himself and his family from enemy attack. To provide and to protect became the unconscious core of man's existence.

Today the role of the male has not really changed. These two elementary factors remain as constant demands. However they have now, because of the changing needs of the Time, often shifted in emphasis from the physical to the spiritual. Nevertheless in some manner, man must still fulfill these instincts in order to establish a feeling of real masculinity.

**Name:** David Wood   **Age:** 68   **Occupation:** Dancer   **Race/Ethnicity:** White   **Where Born:** Fresno, California   **Where Raised:** Fresno, California   **Presently Reside:** Berkeley, California   **Relationship Status:** Married, with three daughters   **Education:** B.A. from U.C. Berkeley, but my real education was getting out into the world and living.   **Socio-Economic Class:** Poor (growing up), Rich (now)   **Any Other Defining Characteristics or Experiences:** Living for 25 years in New York City totally changed my life.   **Philosophical Statement:** Be on time. Work passionately to achieve the best you can, and to accept the results as a part of the fleeting present.

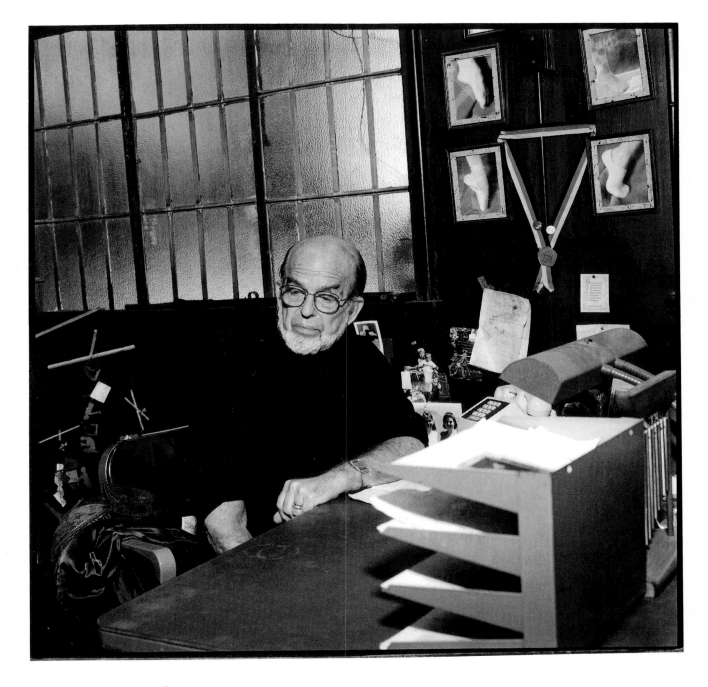

What is it to be a man?
"To be a man is to struggle for validity in a male dominant world that does not allow me to embrace all that is masculine & feminine in one human being"

**Name:** Lyndon Branaugh   **Age:** 32   **Occupation:** Modern Dancer/Choreographer/Teacher   **Race/Ethnicity:** Indian/Asian   **Where Born:** London, England   **Where Raised:** London, England   **Presently Reside:** Tallahassee, Florida   **Relationship Status:** Single   **Education:** Vocational training, no college degree   **Socio-Economic Class:** Parents: working class; I am an artist.   **Any Other Defining Characteristics or Experiences:** I find myself consumed with my own sensations and experiences. I am permanently *in process* to better understand the art of living. I search for peace . . . and hopefully will find *acceptance* before death.   **Philosophical Statement:** It is essential for us to be able to love. We must start by loving, forgiving, and accepting ourselves. From here we can begin to truly love . . . unconditionally. In loving kindness and compassion *know thyself* . . . to then love *others* and ultimately all that exists.

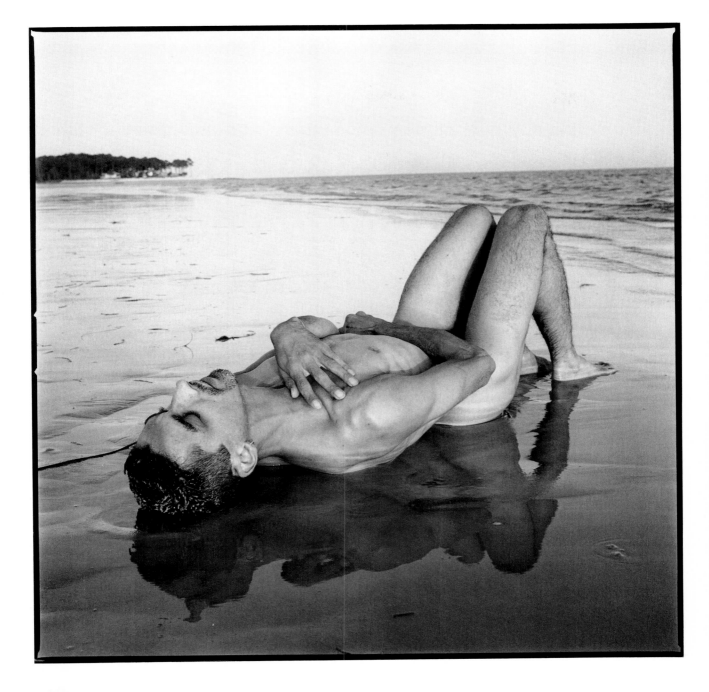

In all my travels I have found this to be the most difficult place to be a man. It might have to do with my European "chauvinistic" upbringing, but I consider myself a rather open-minded, non-chauvinistic male. Here in the USA I see myself put between two extremes as a man. Traditional views, which are still quite prevalent, expect the man to be active, outgoing and to take the initiative in relationships. On the other hand feminism has since the early seventies declared those attitudes as sexist, domineering and disrespectful of women. The difficulty of men in this society is to find their balance between these two extremes. How can a man have healthy relationships with women and maintain a healthy male identity without being stigmatized as a macho? Developing a natural identity as a man is not a gift that is given in the cradle. It is a struggle, and it is difficult. Our fast changing society only gives us the role models of the past. We have to create our own ideas of what it is to be a man.

**Name:** Volker Poelzl   **Age:** 28 years   **Occupation:** Student, but also work.   **Race/Ethnicity:** Caucasian, if you will, or white **Where Born:** Salzburg, Austria   **Where Raised:** Salzburg, Austria   **Presently Reside:** Seattle, Washington   **Relationship Status:** Separated   **Education:** Some college—a degree in social work   **Socio-Economic Class:** Middle class, by Austrian terms, lower middle class by American terms   **Any Other Defining Characteristics or Experiences:** Cosmopolitan Artist/Sculptor. My traveling experience distinguishes me.   **Philosophical Statement:** Discover your strengths and follow your intuition.

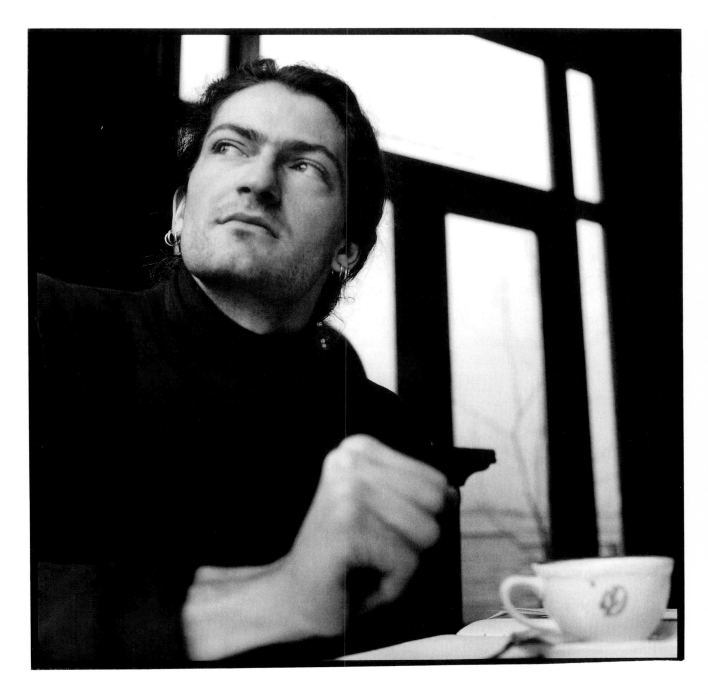

The mainly thing is to hold no fixed view, but rather to remain open and ready to follow the wholesome directions offered by each situation.

However, when we are lonely and insecure we may be tempted to find companionship and belonging by joining some who hold one fixed view against another. Thus we sell our soul and forfeit our life. Only by noticing this tendency completely can we counter it.

True love and peace depend on it!

*Name:* Lee de Barros   *Age:* 56   *Occupation:* Zen Priest   *Race/Ethnicity:* White   *Where Born:* Brooklyn, New York   *Where Raised:* New York City and Rye, New York   *Presently Reside:* Green Gulch Farms & Zen Center, Marin, California   *Relationship Status:* Married   *Education:* Graduate study in Psychology   *Socio-Economic Class:* Upper Middle Class   *Any Other Defining Characteristics or Experiences:* Practicing Zen Buddhism and San Francisco Giant fan   *Philosophical Statement:* There is nothing wrong with life that what's right with it can't fix.

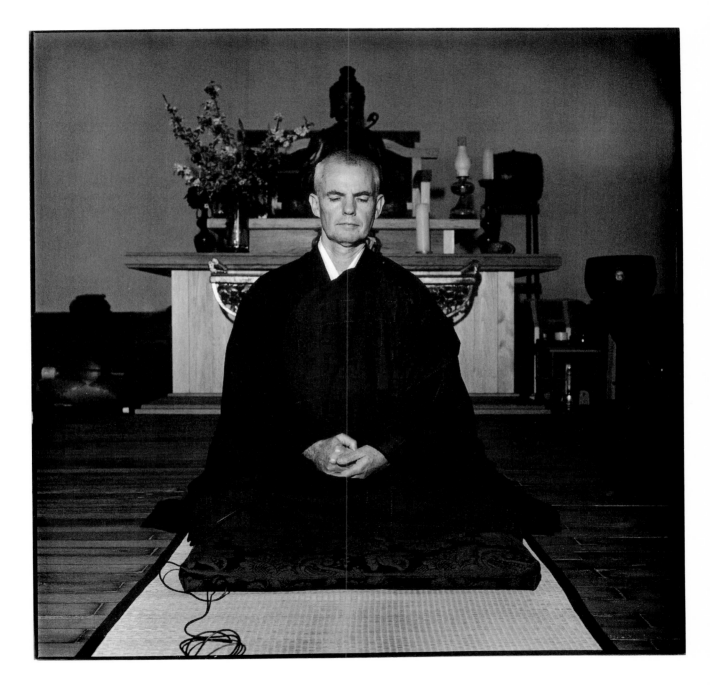

Being a man is understanding the transient importance of our existence. As we are not granted the capabilities of giving birth, we must find the purpose of our existence elsewhere. Perhaps we find it through responsibility and service to those who can, or possibly it is found by way of a unique experience of life. Regardless, a man is a friend; a man is alone; and a man is accountable to himself.

—Daniel S. Kaufman

*Name:* Daniel Kaufman   *Age:* 28   *Occupation:* Artist   *Race/Ethnicity:* Jewish   *Where Born:* New York, New York   *Where Raised:* Los Angeles, California   *Presently Reside:* Berkeley, California   *Relationship Status:* Single   *Education:* Many places, many things, I am not sure what it all amounts to.   *Socio-Economic Class:* I grew up upper-middle class and then became lower-middle class. Now I am somewhere in between.   *Any Other Defining Characteristics or Experiences:* Living abroad, traveling the world, pursuing my passion despite every ostensible rejection, and ultimately succeeding. Watching my father die.   *Philosophical Statement:* You *are* your conscience . . . so live by it. Live your dreams; live for today; live without regret.

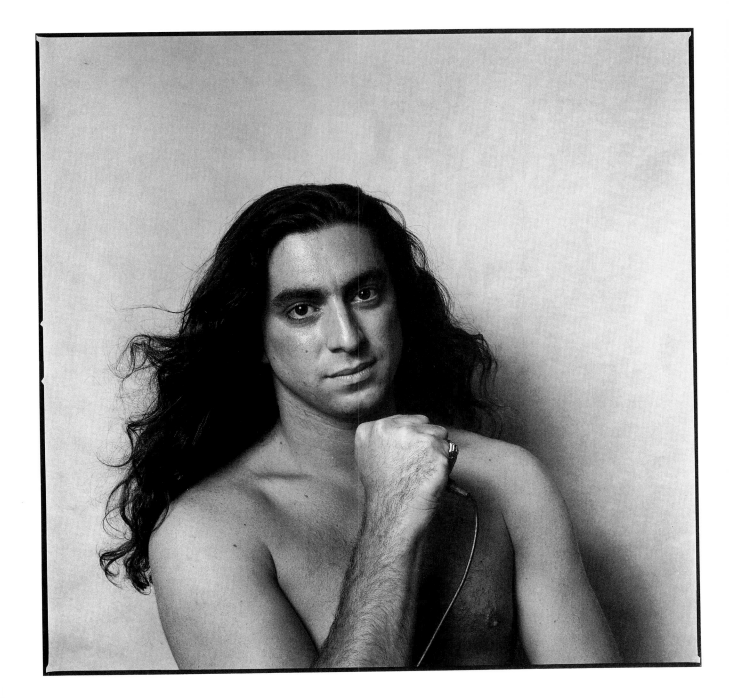

# *Afterword*

## *Encounters*
## *Encounters*
## *Encounters*
## *Encounters*

HOW DID I FIND these men? What drew me to them?

When I started my journey, I did not know what I was looking for. I had archetypes and icons which I sought out (cowboys, farmers, fishermen, lawyers, businessmen, etc.), but the reality of these men rarely corresponded to my expectations. I tried to echo the actual statistical ethnic diversity of this country (12 percent African American, 9 percent Hispanic, 9 percent Asian, 1.8 percent Native America, etc.), but the men I found were not statistics who fit neatly into pockets of what I was missing. For the most part, I found these men through good fortune, fate, and arbitrary happenstance. I embarked on a wild expedition, with no plan other than to encounter men and masculinity in any form. My biggest job was to remain open to the abundance of male variety I might find.

I started the most vibrant leg of the trip by arriving in Boston, with very little money and no specific ideas about whom I should photograph. I charted my course on the basis of the least expensive route out of the airport (the road with the fewest tolls). With visions of the quintessential lobster fisherman, I ended up heading north toward Maine.

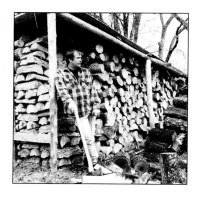

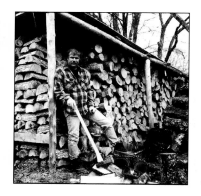

Gas stations and casual stops led me to the very small, insular town of Port Clyde, Maine. There I ventured into the bastion of local knowledge, the general store, seeking such a lobsterman icon. After spending time discussing my project and playing cribbage with the local fishermen, who happened to be on shore on this rainy spring day, I was put on the trail of Teddy McLaughlin (see page 47). Although appreciative of this lead, my gut told me I was being set up, but I took the bait anyway.

My first glimpse of Teddy McLaughlin left me incredibly aware of our physical differences. Teddy exuded a solid, muscular presence that only comes from a lifetime of hard work and physical exertion. Yet he also struck me as a sensitive, caring family man. Once these introductions and first impressions were behind us, we dove into a deep and animated conversation about being men, about taking care of family, about doing what needs to be done— whatever the cost. This discussion weaved its way through a dinner of moose meat and freshly picked fiddleheads (I still don't know what these are), and by the time dessert was on the table, it was after two A.M. and a thick carpet of snow had fallen. Teddy looked at me and smiled. ''I guess you're gonna stay here tonight.''

When I finally left the McLaughlin house four days later, I was like a long-lost relation and was on my way to becoming an honorary town resident. The folks of Port Clyde and the fellow lobstermen were impressed that Teddy had taken a liking to me, but what eventually won their trust was some shared hard work.

One morning at five A.M., I left with Teddy, each of us armed with a chain saw, to go and work on a nearby island cutting trees and brush to clear some land for grazing. There were nine of us from the town, including the owner of the general store. It was obvious to these men that I had never operated a chain saw before, but eleven hours later, as the sun was completing its cycle for the day, the fishermen of Port Clyde looked at me differently. I may not have been full of finesse with that chain saw, but my hard work and effort proved my worth in their eyes.

Having won their trust, the grand finale to this day was that all of these men wanted to discuss my project and pose for a group portrait. It was as though clearing these trees together had also knocked down any barriers between us. The floodgates had been opened, and there was no shortage of opinions on what it means to be a man. What started out as a potential wild goose chase turned into one of my best leads and most memorable encounters.

In the back country of North Carolina, I also had to prove myself. Cole Church (see page 116) could not believe that I had never

been white-water rafting: "How can you write a book on being a man without ever tackling the white waters on a little old raft?" For him, being a man necessitates completing a rite of passage. Two days later, Cole and his buddies had me in the front seat of a canoe, battling class-four rapids on an odyssey down the Chatooga River. After a few nights in the wilderness, over a campfire and many cans of Budweiser, I started to hear the real feelings of men who had never spoken before about being a man.

But not all of my experiences were ultimately welcoming. Some were equally rewarding, but were also frightening, if not downright threatening. I was determined to interview men from inner city areas, however, with this effort came some risks. Through an introduction from John Sweeney (see page 124), I was able to meet Donnell White (see page 42), who granted me safe passage into gangland Los Angeles. My presence in Compton raised some eyebrows and suspicions, but I was very careful not to push any limits or to take any photographs without permission. That day I learned the significance of various tattoos and expressions, and for the first time in my life, I experienced the helplessness which exists in places like these.

Another somewhat unnerving encounter occurred when I wandered into a very rough-looking bar in Gloucester, Massachusetts, where all the action centered around the pool table. This particular billiards room was being run by Malcolm Hartwell (see page 136), an enormous presence, well over six feet tall, easily three hundred pounds, bald, loud, tattooed, and mean-looking. There and then I realized I had to have him for this book.

But approaching such a model of maleness is not necessarily easy, nor are the potential risks enticing. Three hours later, still mustering my courage and nursing my original beer, this larger-than-life pool player looked my way. With his glance came my window of opportunity to introduce myself and this project. "What is it to be a man," I asked.

Without missing a beat, Malcolm replied, "I'll tell you, Danny . . . to be a man you have to know how to be feminine."

When I heard those words gracefully flowing out of this ex-marine, I was both floored and ecstatic. What better response to disprove every preconception I had about this man and male identity in general?

Meeting Don Thompson (see page 78), the official leather daddy of San Francisco, was equally uncomfortable, although certainly not as threatening. Many of the men at a famous "leather" bar

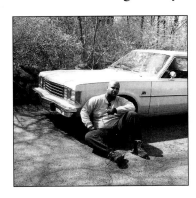 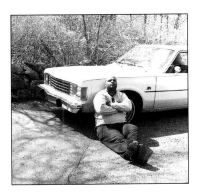 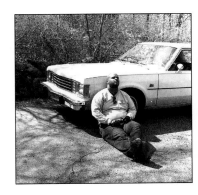

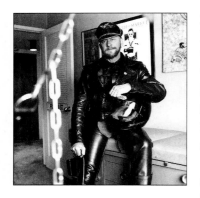

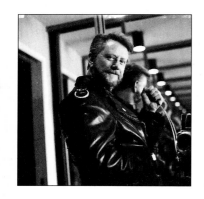

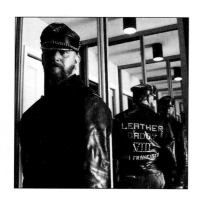

in this city dress in leather, wear chaps, and even carry whips. Many sport tattoos, mustaches, and "stomper" boots. I went there to find a different perspective, and I did. Most of these men were quite intimidating and did not conform to the stereotypical images of homosexuality. But once I got past my own fears, I found Don Thompson to be the charming, intelligent Englishman that he is. Once again, I re-learned the lesson of surrendering expectations.

Approaching a stranger is never comfortable, but was a necessary discomfort to enlist the men for this collection of self-portraits. These interviews usually required patience to accurately strategize on how best to open the topic of discussion. One particularly tricky encounter was with John "Big Spurs" Prude (see page 150). While traveling through El Paso, I heard about this eighty-eight-year-old cow-wrangler, an original Texas homesteader who still ranched as though he were in his twenties. I drove all night and arrived unannounced and uninvited at Big Spurs's ranch the next morning. He was watching his young workers wrangle. Immediately it became clear that I could not just walk up to him and ask him my question. So my hopeful strategy was to sit down on a bench near him and wait for him to make the first attempt at an introduction. Though aware of my presence, he chose not to look my way . . . and I sat there with him for over an hour while he coached his wranglers in the cattle ring.

After some time had passed, I decided to review my strategy, and finally I spoke up: "I drove six hundred miles last night and this morning to meet you."

"That's a lot of miles. You must be hungry."

Big Spurs never looked at me, but he invited me to have lunch with him—the typical cowboy fare of red meat and baked beans. Big Spurs and the other ranchers were amenable and interested in my questions, which I attribute more to a satisfying meal than to my charm. They all immediately had answers and ideas about how to photograph themselves. Two wanted to be with their horses,

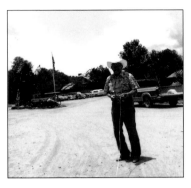  

one with his truck, and Big Spurs wanted to show off his family ranch. With the ice broken and the thumbs-up from Big Spurs, my work at Prude Ranch was quite easy.

Finally, I discovered men by following my own interests and boyhood ambitions. These fantasies put me on the floor of the New York Stock Exchange and in the driver's seat of a fire truck racing to a three-alarm blaze on Manhattan's Upper West Side. While interviewing firefighter Eddie O'Mahoney (see page 158), the alarm sounded.

"Grab your gear and follow me."

Sliding down a fire pole with a large camera and tripod is not easy. In fact, it is downright stupid, but it was also incredibly exciting. Over the course of the day that I spent at Firehouse Number 35, I rode in two fire trucks to four different alarms. Each

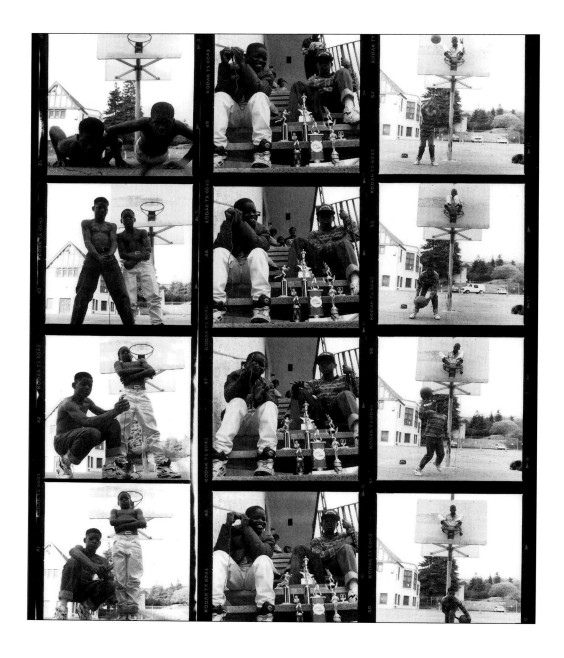

time I manned a different position on the truck, watching as the men scrambled to prepare for the unknown flames that awaited them.

Completing this book also brought me into the swamps of Louisiana and into a Zen Buddhist temple in Marin County, California. Each experience rivaled the next and taught me more about how men live, why they act the way that they do, and what they value most. I have grown more aware of the concerns that these men face, and very often these issues are revealed profoundly in their images. In fact, each subject had his own mystery to share and solve. These are all individuals with their own agendas and concerns. And they invite us, the viewers, to try to understand their enigmas and discover their secrets. It is for this reason that we have to look deep into these images to find out who these men are.

Each photo session was slightly different. In some cases the subjects would only take one image of themselves. One said, ''That's it. I hope you got that, because that is all you are getting.'' But most of the time, the subject enjoyed being in front of the camera and wanted to take several photographs. The photo session with Bo and Adrell Burrell (see pages 108 and 106) was particularly rewarding and resulted in many wonderful images. This windfall of fabulous images also made the photo selection all the more difficult. But, in this case, because each young man gave me a handwritten statement, I had the luxury of using two different images.

It just happened that both of the images chosen were looking upward at the boys. I chose the image of the boys on the stairs with trophies because of the extra parts of their story which were told. The look of the building, the attitude of the two (one smiling, funny, and energetic, the other serious with a sense of responsibility to look after his slightly younger brother), and the presence of the family peeking over the ledge, all of these elements contribute to our understanding of the Burrell boys and the lives they lead. I

179

  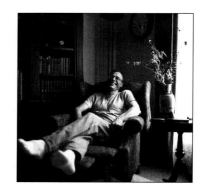

did not understand the presence of the trophies until long after I had selected the image. Being one of the earlier interviews in this project, I did not make the connection of men and their prizes or accomplishments. But now that I look back on this image, I am extremely glad that this one was chosen.

I also chose one image over another because of its content. In Keith Gockel's self-portrait (see page 122), he had surrounded himself with clocks. The presence of time is always an interesting symbol, but for a man with AIDS, the image becomes even more powerful.

Once entering the realm of the symbolic, it is interesting to look beyond the instant image, deeper than an initial viewing. Darrell McLaurin wrote, ''A man is happy in his environment. . . .'' (see page 146). In his biographical sketch, he also wrote that he is

a ''proud African-American gay male dancing-singing student,'' but the place where he chose to photograph himself, where he was ostensibly the happiest,

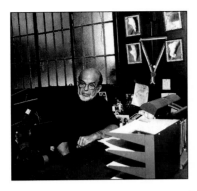 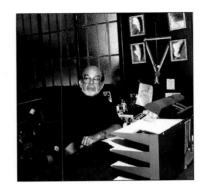 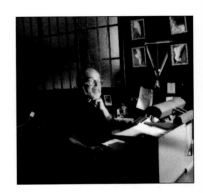

was in his closet. The duality of his image juxtaposed against his words is fascinating.

Placement of the subject is another element of interpretation. Where is the subject in the frame? The center has different connotations than the sides. Close focus is different than farther from the camera. Where is the subject in relation to the props and setting around him? David Wood (see page 160) sits at his desk with a photograph of his family behind him. So how does work fit into his life? The power of these elements should not be dismissed.

The expectations of capitalism and consumerism existed throughout. Gustavo Zepeda (see page 88) had an immediate answer to my question: ''Being a man is being expected to produce results.'' But he felt that he needed an additional prop to complete his image of monetary success: a cigar. The use of previously established roles as icons of identification was a constant throughout compiling this book. In my experience, men are generally try-

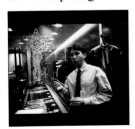 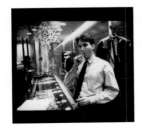 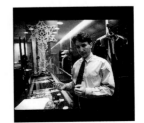

ing very hard to be successful. Usually that success is measured in monetary terms, but often it is measured in other terms as well. Even boys feel that they are judged or are in a kind of competition with each other; consequently, many of my subjects chose to be photographed with their trophies or other proofs of success. Some men posed in front of their certificates, their degrees, their medals, and even photographs of their families. These all seem to be symbols of competition against which men measure themselves.

It is also striking to me that so many men placed themselves with their favorite possessions. Numerous men photographed themselves with their horses, or their trucks, or their motorcycles. Whereas comparatively few photographed themselves with other people, many chose objects of success and power or symbols of masculinity to have in their self-portraits. As the facilitator of these images, I would usually be asked many questions, but my answer was always the same. "It is your self-portrait; you can do with it what you like. I'll find a way to make it happen if I can." Even so, the overriding common element in these portraits is that most men chose simple images of themselves, and almost all chose to photograph themselves at their places of work.

# *Conclusions*
# *Conclusions*
# *Conclusions*
*Conclusions*

THERE HAVE BEEN countless speculations about male behavior, infinite attempts to understand who men are and why they do what they do. But maybe the real answer lies in how men think of and identify themselves. Do men feel pressured to live up to a notion of identity which requires a certain demeanor and set of priorities? It is no revelation that the rules of social interaction have changed, but where are we now? What are the new guidelines and expectations? The age of reason, industry, and modernization has made sexual equality a genuine possibility, but men still retain the ostensibly dominating role in this society. Issues of physical strength no longer logically preclude women from earning money on parity with men. Computers, telephones, automobiles, machinery—these tools of our modern economy can be used equally well by women and men. Even so, men still wield much more political and economic clout than do women. Why has equality not been achieved? What has changed? What is the current status?

The past twenty-five years have brought these issues to the forefront of the social discussion; however, they have done so primarily in relation to women. The feminist movement has prompted

women to seize the opportunity to reinvent themselves and to redefine their roles. Men have not really done the same for themselves, however. And yet the role changes by women have greatly affected the very nature of male psyche. The rapid social changes which occurred in light of feminist redefinition have certainly prompted adjustments by men, but there has been no unifying opportunity for male self-examination. The qualities which previously embodied the myth of the American male (individuality, aggression, and ambition) have been relegated by some to the negative characteristics of oppressive conduct. But these attributes still remain an integral part of the masculine ideal. Popular icons of masculinity prevail in advertising and the media. Cigarette companies promote a strong, tough, solitary cowboy, more concerned with conquering the untamed west than communicating with his fellow humans. Razor/shaving companies glamorize an athletic businessman, a man's man, who wears expensive clothes, is surrounded by adoring women, and yet still finds time to sweat in the name of competition. Where do these common images exist in terms of new social definitions? This is a time when modern definitions defiantly challenge traditional values. For centuries men have taken on the role of the provider, while women have been the nurturers. But now that we have the opportunity to re-examine such a conventional division of responsibility, the elements of this society must define themselves differently.

In these precarious times, men are unsure of how to behave or of what is appropriate. It seems that society still lauds aggressive ambition, but where does aggression become abuse? When does strength and motivation become oppression? Can one be old-fashioned and yet modern at the same time?

Men and masculinity have been in an increasingly precarious and ambiguous position for quite some time. Men have a hard time relating with women, other men, and even themselves. Historically men have been given neither the vocabulary nor the opportunity to express themselves. However, women and femininity retain those

close associations with language, intuition, and feelings. For men, communication remains shrouded by the fear of emasculation. There is no communal forum for men to talk about subjects as tender and as tentative as their masculinity. To speak of gender issues with other women would be to invite comparison of victimization, and yet, to speak with other men is to risk being sexually suspect. So men have not expressed themselves as they might have, but, given the opportunity and encouragement, men have an enormous amount to say about the changing social climate and their place in it. Even though these men cross all social boundaries and represent vastly distinct populations, there is a theme which permeates them all: the desire to speak. I found that men desperately want to communicate but either do not know how to express themselves or do not have the opportunity. *To Be a Man* provided an opportunity.

So, what does make us men? I certainly know neither what makes me a man nor what is implicit about being a man, except that I am very much aware of what men cannot do. Men cannot bring children into this world. This was repeated many times over the course of my journey. Perhaps the notion of responsibility so commonly associated with masculinity comes from a sense of lack, from an inability to reproduce. Beyond biology, modernity and social evolution have equalized what previously defined gender roles. But equality, as defined by sameness, has most definitely not been achieved. In its place is much confusion, conflict, and disagreement.

Certain case studies actually display better gender acclimation. In the rural areas (where reliance on strength is still an important part of the way of life) gender lines seem to be less volatile. In these areas off the beaten track, away from modern cities, where older (ostensibly patriarchal) values are still intact and unquestioned, there seems to be less gender conflict. The roles of men and women remain clear by necessity. Their lives appear extremely tough and yet there is much which is rewarding and imme-

diate. In the case of the McLaughlins, Teddy fished and hunted, and Heather (his wife) canned the food and stored it. Theirs is a partnership of equal work and recognition. Teddy might work eighteen hours a day, but he makes time to be home with his babies. For Heather, mothering is a full-time job which allows for the opportunity to raise a vegetable garden. Necessity has given them these roles, and their respect for what the other does is admirable. The real added benefit is that neither is self-sufficient but is in fact completely dependent upon the other. Perhaps this allows Teddy to remain sensitive, childlike, playful, and, at times, even emotional, while Heather embodies much of the strength and independence women deserve and desire.

This is in no way to conclude that our modern urban life-styles are disconnected and bad while Heather and Teddy's *old-fashioned* ways are successful and good. However, the confusion which characterizes so much of male identity does not exist in the same way in those more rural life-styles. The modern age has provided us with the means for easier living, but human interaction has not yet caught up with science, the mechanization of industry, and our economy—and at the rate at which change continues, social mores, taboos, and archetypes are not going to settle into anything livable too soon.

Saying that, vast changes have already occurred. When separating the subjects in this book by age, it is my own generation—men in their late twenties and early thirties—that is most apt to characterize male existence as confusing. Generally, those who are older still see themselves as being the leader, provider, and protector, while those who are younger (and usually urban) are less likely to draw any gender lines at all.

Like the rest of the world, manhood and masculinity is constantly evolving. But perhaps men do not control the status quo as much as the word "patriarchy" implies. The men in this book speak overwhelmingly of their masculinity in terms of responsibility, duty, job, and status. The real power and freedom to choose

lives of individuality elude men very much as they elude women. Traditional masculine roles inevitably seem to lead to the identification of self with occupation and profession. The advantages of modern life have not yet been absorbed into the fabric of social relations, into a land defined by freedom and plenty, as opposed to a country of duty and struggle. What seems to be evolving is an increased polarization of the sexes, but if we reserve judgment and instead try to see different perspectives we will better find new realms to bridge communication. Feminism has provided the opportunity for the redefinition of women; perhaps now is the time for us to redefine what it is *to be a man*.

*A Personal Note . . .*
*A Personal Note . . .*
*A Personal Note . . .*
*A Personal Note . . .*

ON AUGUST 15, 1992, I stared at my father's dead body. His death certificate read: *Pulmonary Failure due to Scoleotic Pneumonia.* In truth, however, my father died five years earlier when he filed for bankruptcy. He was of a generation of men who see their primary purpose in life as being the provider and protector. For many years he was extremely successful at taking care of himself and his family's financial needs. An immigrant, he had conquered the American dream and excelled at the rules which this society dictated to him. If we had lived in the wild, his role would have been to prevail over hunger and physical danger, but since we lived in the jungle of enterprise, his job was to make money. Michael Kaufman so deeply believed in the consumerist codes of this society that when bankruptcy came, he thought he had nothing else to offer. There was no identity behind those achievements and finances. For five years he tried valiantly to win back his earning potential, but the eighties and nineties were not to be a time for comebacks. When his money went, so ultimately did his life. If anything, he died of shame, ashamed that he had failed as a man. In

fact, he died two weeks before the bank finally repossessed our house.

How could a man of such intelligence, imagination, and strength have such a dramatic misconception of his identity? When did virility become equivalent to prosperity? How is it that being out of work and/or money makes a man feel worthless and faltering in his masculinity? As I looked over the shell that was my father, it became clear to me why I have been so passionate and obsessed with the exploration of male identity.

During the last two years I photographed more than one-hundred-and-thirty men, and I spoke with hundreds more. What is most striking to me is that seventy-eight of them photographed themselves at or around their place of occupation, more than sixty percent. And of the fifty-three who did not, all but four of them were either retired, unemployed, or students. If this is truly representative of the way that men identify themselves, what will happen to them when they retire? . . . if they are fired? . . . if they file for bankruptcy?

The cult of personality surrounding the mythical male is one of achievement and productivity, and not one of communication and sentiment. The great majority of personal statements in this book reflect a notion of responsibility and duty and of providing and protecting. But who are they providing for, and what are they protecting? Being a family man, a husband, and a father is not always compatible with being a provider. Encountering each of these men, I reached a deeper level of understanding my own father, a renewed compassion for the problems that he faced at the end of his life.

Most of the men in this collection of self-portraits realized themselves with particular sobriety and solitude. For them, *being a man* is serious business. For the most part their poses are not smiling, happy ones; rather, they often present stern expressions of duty and responsibility. Many times I was overwhelmed by the urgency

with which they spoke of their identity. These men had clearly formulated their thoughts and words long before I had ever approached them, but they rarely had the opportunity to express them.

Perhaps the most disturbing theme is that of male solitude and isolation. Many of the men wrote about community and family, but almost all of them photographed themselves alone. Whereas comparatively few photographed themselves with other people, many chose objects of success and power or symbols of masculinity to accompany them in their self-portraits. Many men included prized possessions: a favorite horse, or truck, or motorcycle, rather than friends or family. The exceptions to this rule were found mainly among my younger subjects. Three of the five boys I photographed chose to have their brother(s) with them. Maybe those relationships are more important when we are younger, or maybe we just lose touch with them as we get older. Here again, I regained a new appreciation and consciousness about my own father; I can now appreciate his solitude.

Men consistently characterized masculinity in terms of women, not merely in opposition to femininity or as a way of posturing to attract females, but also in terms of relating. The obvious case is that of Malcolm Hartwell, who wrote that being a man is getting in touch with his *feminity* (sic) so that he could better communicate with his girlfriend. But beyond Malcolm, nearly twenty percent of the men I interviewed could not identify themselves except in terms of women—that being men was caring for, communicating with, and in some ways, not being women. Words like: provide, protect, strength, stability, leader, security, and support emerged when men described themselves.

If our culture recognized personal emotional achievements as much as monetary ones, there would be fewer cases of oppressive expectations and destructive competition. We need only to look to that statistic of mortality after retirement (i.e., the largest percentage of male deaths occurs within eighteen months of retirement) to

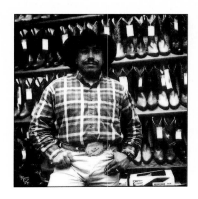
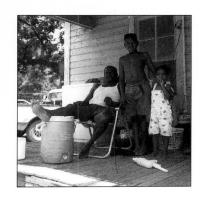
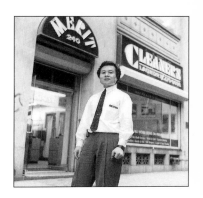
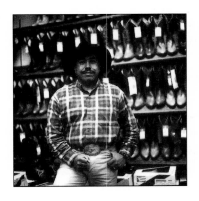
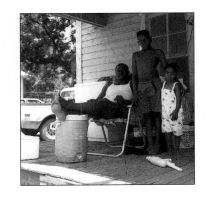
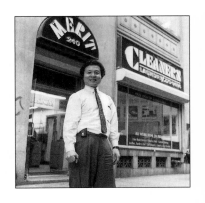
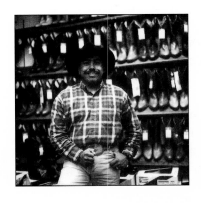
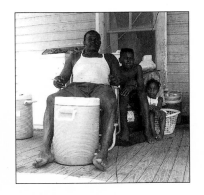
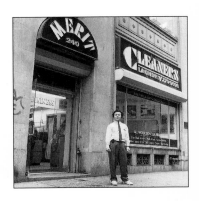

see that much of what is defined as male identity is killing us. What will happen to George Jimenez if he cannot *take care of his woman?* What will happen to Henry Mims if he cannot work? If Steven Yi loses his business? Will these men cease to feel masculine? What do they have to fall back on if their occupation or ability to provide fails them?

There is tremendous honor among these men and associated with masculinity in general. For the men I photographed, the definition of manhood is so related to issues of sacrifice and reliability, there seems to be little reason for any feelings of shame or worthlessness.

In retrospect, I wish that I could have been more of a friend to my father, more of a beacon of support to help him better assess his own value to the world. After thinking about him in terms of the many men whom I encountered during my travels, I remember Michael Kaufman with great respect and distinction.